BARN DANCES & JAMBOREES ACROSS KENTUCKY

D1572053

BARN DANCES
DANCES
& JAMBOREES
ACROSS
KENTUCKY

J.D. WILKES
Foreword by JOHN COHEN

Charleston London

THE
History
PRESS

Published by The History Press
Charleston, SC 29403
www.historypress.net

Front cover, left to right: 1950s hillbilly band featuring Fonzy Davis on WNGO, Wingo, Kentucky.
Courtesy Bristol Broadcasting; Rosine Barn Jamboree. *Photo by Carey Gough.*
Back cover, top to bottom: Layne Hendrickson and the author at Earl's jamboree, Olive,
Kentucky. *Photo by Roman Titus*; Scottie Henson, Marshall County, Kentucky. *Photo by the
author*; Betty Dobson at the Hotel Metropolitan, Paducah, Kentucky. *Photo by John Paul Henry.*

Internal illustrations by J.D. Wilkes.

First published 2013

Manufactured in the United States

ISBN 978.1.62619.268.3

Library of Congress CIP data applied for.

CONTENTS

CONTENTS

Contents

FOREWORD

J.D. Wilkes takes us on a journey through homemade music in Kentucky to places where trained folklorists and academics rarely go. He is in pursuit of an ambitious, unprecedented and unheralded project: to get to the heart and spirit of rural country music as it existed and exists today. He has done the grand tour of little-known music gatherings across the state, identifying countless jamborees, barn dances and oprys. He writes in a way that is "enjoyable and informative." He says, "I've tried to include the flavor of each of Kentucky's basic regions, along with personal anecdotes from my travels and tours. I also tend to wax poetic from time to time."

Perhaps his study could be reduced to a compilation of maps and charts, but that would entirely miss the rich material he has uncovered and the even richer descriptions and details that he gives here. His idea seems straightforward in concept but becomes infinitely complicated. We sense a lively mind at work, delving into history, geography, issues of commercial versus local music, always probing to get to the spirit that has energized Kentucky music for several hundred years. He looks for the continuity between past and present.

As an outsider (I'm from New York), I find this material absorbing—it puts a frame around the Kentucky music that I've loved and lived with since 1959. I think it will open the eyes, ears and hearts of people in Kentucky, revealing to them what is already there but (for good reason) always a little hidden, off the main highway. To get there, J.D. Wilkes has driven through enormous cornfields.

FOREWORD

Roscoe Holcomb from Daisy, Kentucky, once told me:

> *I used to play for square dances a lot, I've played 'til the sweat dripped off my elbows. Use'to a bunch of us get out, maybe go to a party somewhere. And after the party was over the moon'd be shinin' bright. You know we'd all start back home and gang up in there in the middle of the road. Somebody'd start his old instrument, guitar or banjer or other and just gang up in the middle of the road and have the awfullest square dance right in the middle of the highway.*

Roscoe's memory represents the old spirit as it once was and still could be. This book amplifies Roscoe's memory and sheds light on the broader community of Kentucky music today.

JOHN COHEN
Putnam Valley, New York
August 2013

ACKNOWLEDGEMENTS

I wish to thank the following for their assistance: John Cohen, John Harrod, Larry Webster, Joe Fothergill, K. Layne Hendrickson, Nathan Blake Lynn, Carey Gough, J.T. Oglesby, John Back, Mike Oberst and T Claw. All the extra folks who shared their stories are cited throughout the book. Thanks again to you all!

This work is dedicated to my late grandfather, Van D. Fiser, my parents, Stephen and Linda Wilkes; my sister, Summer Rhea; my wife, Jessica Wilkes; and everyone in Kentucky who is keeping alive the old traditions that set us apart from a world gone mad.

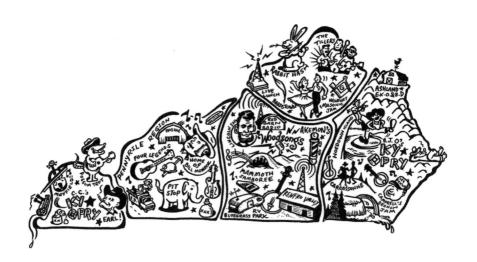

Introduction

THE LIFE OF A TRAVELING PICKER

As a professional harmonica player and singer in a hillbilly music group, I've played my share of festivals and nightclubs since the age of sixteen (I am now forty-one). You name it, I've played it. From a boot scoot to a prison, a barbecue joint to a Masonic lodge. From fish fries to "pig-picks," juke joints to paddle-wheelers. Pool halls, mini-malls, parades, pubs, clubs, churches, casinos, coffee shops and drag strips. Let me see, did I leave anything out?

Every gig came with its own joys and victories, like a "packed house" or profitable merchandise sales. But there were often just as many headaches, from vehicles breaking down to bands breaking up. Sometimes the crowds would hate the music or, worse, they'd be indifferent. Too many college bars are crammed with smug hipsters doing that "too cool for school" routine. They stand there waiting to make sure it's "okay" to like the band rather than determine for themselves. What's up with "kids these days"?

Don't get me wrong; I'm no martyr, but I have devoted thousands of thankless hours to driving through the night from hotel to hotel, gig to gig, waiting to load heavy gear up and down the stairs. There's the set-up, the sound-check and the show. Six hours, later it's the tear-down, the settle-up and the drive-on. Most of the time this strange lifestyle is a "hurry up and wait" situation. Someone invariably shows up late, be it the soundman, the promoter or, worse, the guy with the paycheck.

JAMBOREES

After souring somewhat on this way of life, I've come to discover that those old get-togethers out in the sticks were oftentimes a lot more fun than real gigs. They carry on the age-old, noble tradition of making music for the right reasons. As Thomas K. Wolfe describes in his book *Kentucky Country*:

> *If we could be transported into Kentucky during the year 1850, we would find people enjoying music from square dance fiddle tunes to hymns. People would be making the music themselves, not passively listening to it on the radio or a record player.* [They would be] *much more involved than most music fans today. The instruments, especially fiddles and banjos, were homemade with little of the singing or playing style learned from books. It was a people's music and for many it was next to their religion. Their only means for reflecting their values, ideals or aspirations.*

Jamborees are the closest you'll come in modern times to capturing this feeling. They are especially refreshing for a professional musician like me, mostly because there is absolutely *zero* pressure to make money, load a bunch of equipment or impress a cynical crowd.

I became interested in this subject in the early 1990s, when my band and I went to record our first record (or cassette tape, as was the format then). My bandleader, Layne Hendrickson, chose an obscure little studio up on a steep, kudzu-choked hill in Hardin, Kentucky. "The Hilltop" was a concrete block building that served as both a recording room and a weekend jamboree for local old-timers. The engineer was a seventy-plus-year-old hillbilly cat named Leroy Henderson. Leroy still greased up his hair and wore thick horn-rim glasses. An inch-long "ghost finger" of ash hung perpetually from his cigarette as I watched him twist knobs and squint at the settings. He owned several vintage microphones and kept his dust-covered recording console over in a darkened corner. Styrofoam egg cartons were chicken-wired to the walls for an anechoic effect. Vintage chrome-and-Formica dinette sets and lawn furniture sat askew on the concrete floor. I imagined all the old greasers rocking out on a Saturday night to the tunes of Hank Williams, Johnny Cash, Johnny Horton and Carl Perkins. Suddenly, I felt like I had either stepped back in time or been sucked into the Twilight Zone. This dreamy scene of nostalgia blurs in my mind more and more with each passing year.

Such live country music shows are all over our fine state, from Paducah to Pikeville, Louisville to Line Fork. They have roots in old-time barn dances but

are mostly inspired by "barn dance" adaptations like WSM's *Grand Ole Opry* and other broadcasts. You know the scene: a stage, a band, an emcee, rows of seating, smiling faces, a folksy backdrop, maybe some hay. In the early to mid-twentieth century, there were many programs on AM radio akin to the *Opry*, like WLW's *Old Fashioned Barn Dance* at Renfro Valley, CBS's *Plantation Party*, or the Fonzy Davis show on WNGO in Graves County, Kentucky. Just about every broadcaster from the 1930s to the '50s had a "hillbilly" or western music show. They featured live performances from the region's hottest talents. It was a cheap way for station managers to kill airtime and attract advertising, and it often led to the discovery of a "country music star." The wild success some singers enjoyed resulted in the release of millions of 78rpm records, another relatively new and popular medium at the time.

Today, smaller-scale "oprys" and "barn dances" are organized each week in towns across America's rural heartland and South. They can be held anywhere too, from gazebos to barns, outbuildings to radio stations, log cabins to boats to mini-malls. It's always a welcoming, down-home experience that oftentimes features square dancing, cakewalks or clogging. I have sought out these events from one end of the state to the other, not only to get in a few banjo lessons (my new favorite instrument) but also to catch a glimpse of a generation whose culture is disappearing. As the World War II/Korean War generation is replaced by Baby Boomers, Gen-Xers and Millennials, we will see the near-eradication of America's original rural culture. Theirs was a lifestyle and a sensibility that predated pop culture and the urbanized attitudes of the "Me Generation." Those reared in the poverty of the Great Depression perhaps had more in common with the Bronze Age than the Computer Age of their own century.

WHAT'S IN A NAME?

It is now worth pausing to point out the difference between an opry, a barn dance and a jamboree. Really, the terms are interchangeable and it depends on who you're asking. A jamboree can mean any "noisy merrymaking" (according to the dictionary), but it would seem that a barn dance, per se, is predicated on the notion that such merriment must occur in a barn. However, some have certainly taken place in the yard *around* a barn (such is often the case in Rabbit Hash) or on a stage decorated like a barn (like the Hyden Bluegrass Jam).

Traditionally, the barn dance was an event larger than your average informal pickin' party; it was a gathering of many neighbors within a community. This had been the case for centuries as German polkas and Scots-Irish Ceilidhs occurred in barns. It is likely that as long as there have been barns, music and a reason for people to celebrate (and court the opposite sex), there have been barn dances. Indeed, the painter Brueghel the Younger painted a scene of frolicking commoners in his 1616 work *Wedding Dance in a Barn*.

When the Depression hit America and the war raged later, many farming folks became displaced to urban work environs. The entertainment industry, now in league with the new medium of radio, conceived barn dance programs for a homesick market. The first of these radio adaptations was the *National Barn Dance*, aboard Chicago's WLS. Using a medicine show–inspired format, program directors sneaked in ads between the acts to increase revenue, a formula that persists today.

The term "opry" was coined when WSM program director (and former *National Barn Dance* originator) George D. "Judge" Hay launched the *WSM Barn Dance* on November 28, 1925, in Nashville, Tennessee. Following an opinionated remark aired over the *Grand Opera* program that preceded his slot, Hay voiced the following:

> *Friends, the program which just came to a close was devoted to the classics. Doctor Damrosch told us that there is no place in the classics for realism. However, from here on out, for the next three hours, we will present nothing but realism. It will be down to earth for the "earthy."* *For the past hour, we have been listening to music taken largely from* Grand Opera. *From now on, we will present the "Grand Ole Opry."*

Hay cued harmonica player DeFord Bailey, and a tradition was born. The *Grand Ole Opry* can still be heard over AM airwaves today, making it the longest-running continuously broadcast country music radio program.

The trend that the *National Barn Dance* and the *Grand Ole Opry* inspired has even lasted into our twenty-first century. However, the modern barn dance broadcast peaked in the century prior, perhaps with the creation of the hit TV show *Hee Haw*. But as one generation begets the next, time has a way of eroding old traditions. Technologies bring along flashy new trends for younger consumers, and before you know it, you've got a country music industry that cranks out formulaic anthems of the worst southern

stereotypes. Now air-conditioned concert halls replace the poor old drafty barns of yore.*

Despite the progress of our modern times, some old-timey trends, like fiddle music, square dances, quilting and backyard farming, are making a comeback. New jamborees thrive in the underground thanks to our innate yearning for identity and cultural connection. Hollywood, having defrauded and ridiculed the South with countless spoofs and slam jobs, has recently discovered it can make more money by marketing movies to the very people it has debased en masse. Movies like *Cold Mountain, O Brother, Where Art Thou?* and *Deliverance* feature terrific soundtracks (ones that perfectly mask the backhanded politics that still accompany a hidden agenda). Indeed, it seems every time a lively bluegrass soundtrack hits the mainstream, a new generation of traditionalists is conceived. And new picking parties and barn dances spring up to fill the need.

This circuit of live local jamborees is run by strong, colorful personalities—folks particularly enamored with their own southern culture and/or rural identity. They might even have a particular claim to fame. Perhaps they once played the *Grand Ole Opry* or the *Louisiana Hayride*. Maybe they once recorded at Sun Studios in Memphis or rubbed elbows with the likes of Loretta Lynn or Elvis Presley. Regardless of their accomplishments, the jamboree couldn't exist without them or the folks they inspire.

There is most always a congenial, family-friendly feeling at a jamboree. A "no drinking, no cussing" policy can be expected (though some of the more ornery patrons might sneak the occasional jug of homemade whiskey or wine). Decorations might include American and Confederate flags (flying peacefully side by side), Hank Williams posters, country music playbills, Texas longhorns or other taxidermy and miles and miles of bunting. But no matter where you go, from Rabbit Hash to Possum Trot, variety is the name of the game.

Most, if not all, of these jams are open to the public, though many are just not publicized. Few are even broadcast on the radio anymore. Rather, they are made known through a word-of-mouth network within the local community. Despite that, I often wondered why there wasn't a solid source of information on jamborees, especially in my home state of Kentucky. Not even the Internet could provide a decent listing. That's because one hadn't been compiled…yet!

*. The Rosine Barn Jamboree and the Black Barn in Conway, Kentucky, are rare in that they still take place on unpaved floors in real rustic barns.

So, with the permission of these small-town affairs, I have assembled a somewhat ambitious compilation of Kentucky jamborees, barn dances and oprys. I hope you find the following entries enjoyable and informative. I've tried to include the flavor of each of Kentucky's basic regions, along with personal anecdotes from my travels and tours. I also tend to wax poetic from time to time, citing other sources of inspiration. Folklore and history have always informed musicians and their handicraft. Why not incorporate them into the richly edifying story of the Commonwealth's "barn dance" tradition? There will be interviews with local experts, librarians, historians and other folks far smarter than I. Entries on square dances, Irish jams, juke joints, festivals and paddle-wheelers will also be included, as well as any other traditional get-together. Again, variety is the spice of life.

However, by no means is this list of events meant to be exhaustive. Picking parties can take place in anyone's garage or living room or basement… anywhere. Hell, I have one every night on my couch, but my wife and I are the only ones in attendance. In this book, you will find only those events that announce open invitations to visitors. Bear in mind that there is no way I could list every traditional music event in our state. Neither will this work suffice as a textbook for country music or radio historians. However, I have tried to supply the reader with an informational overview of Kentucky's traditional music get-togethers as they occur today in the early twenty-first century. As Berea, Kentucky's jam leader Donna Lamb assured me, "It's important just to get the ball rollin'." And that's just what I aim to do.

Having said that, please enjoy and frequent any and all of the "socials" listed in this book. I believe it is important to uphold the indigenous culture of one's homeland, no matter who you are or where you come from. Being a child of Kentuckian parents and a Kentucky Colonel myself, I consider this work to be a valentine to the culture and music that moves me the most—and to the humble people who continue to carry it on without the expectation of fame or fortune. This book is dedicated to them.

Note: Italicized titles represent those events that are carried over radio, as I consider them to be a broadcast "program." Other terms not to confuse would be:

OLD-TIME MUSIC: Traditional American tunes with blended Euro and Afro origins; usually performed acoustically and often on fiddle and banjo.

BLUEGRASS MUSIC: Bill Monroe's formalized, concert version of old-time music, emphasizing musicianship, blues scales, syncopation and tight vocal harmonies.

HILLBILLY MUSIC: A generic term for old-time, bluegrass, rockabilly or other derivations of rural-themed music from the South. Some view the term "hillbilly" as a slur.

ROCKABILLY: The first form of white rock 'n' roll. Born in the 1950s and popularized by Elvis Presley. Its purveyors also include Charlie Feathers, Jerry Lee Lewis, Johnny Cash and others on the Sun Records label in Memphis, Tennessee.

SQUARE DANCE: A traditional folk dance for couples, subdivided into the Modern Western and traditional styles. The latter is less standardized and allows for regional interpretations and live music.

CONTRA DANCE: A traditional couples dance with New England and European roots. Some contra dances are akin to the Modern Western square dance in that they involve more complicated, swinging patterns.

All information is subject to change. The very nature of a "picking party" requires the willingness of its participants to show up. Locations change and, tragically, old-timers pass away. Please phone ahead before planning your trip.

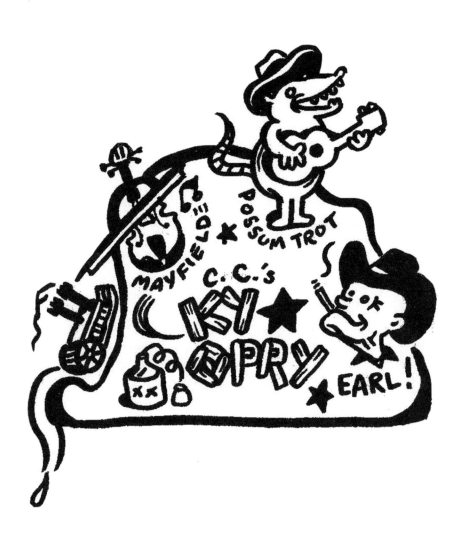

THE JACKSON PURCHASE

The "Snake Oil" Roots of Show Biz

The dusty panel van heaves to life with a backfire. A ring of black smoke ascends as the moving parts sprocket like a tinker toy. Soon, the truck is in motion and sputtering down a Depression-era dirt road. In time, it will approach the muddy whistle-stop of Maxon Mill, Kentucky. A wizened old witch doctor sneaks a peek from the earthen doorway of her mud hut. Farther down, the rattletrap rumbles past another old soul who peers through his curtains with sad eyes. The ghastly old gentleman is bedridden from the effects of "rabbit fever" and cannot attend today's festivities—nor anything else for the rest of his life. All the other folks in town will be there though. They wouldn't miss it for the world. It happens every year.

Gears grind and wheels spin through the mud of the low-lying Strawberry Festival in Paducah, Kentucky. The lanky driver pulls to a stop and straightens his collar. Before stepping out of the truck amongst the gawkers, he wrings the tin lid from a can of Stein's Burnt Cork, careful not to stain his white cotton–gloved hands.

A drop of spit falls from his lips. A sponge is swept across the surface of the cork and applied about the face and neck. A few broad expressions practiced in the mirror, and he is out on his feet. The sound of silver rattles in his clothing as he ambles through the festivities to just the right spot, and then down plops his fruit crate. A throng of white folk soon gathers in the kerosene light, and it's time to go. With a jaunty leap, he is atop the

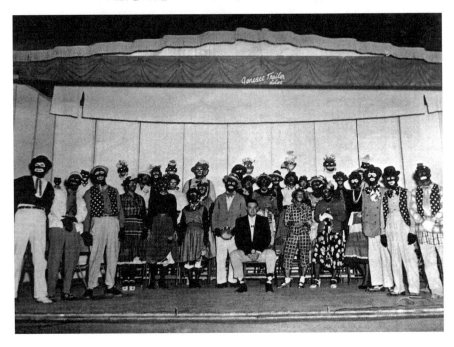

Blackface minstrel shows emerged in the nineteenth century as the first American pop culture craze. Minstrel performers would find a home in the various medicine shows and barn dance broadcasts of the twentieth century. Vague aspects of minstrelsy persist to this day, from Blues Brothers skits to "white rappers." This Calvert City minstrel show took place in the 1950s. *Courtesy Carol Vaughan.*

makeshift wooden stage. Two pairs of spoons emerge from his pockets, and the music begins. A rhythmic metal clack accompanies his song sung loud and proud: "Old Man Mose is dead!"

"I believe. Yes, I believe. Oh, I found out. Yes, I found out…that Old Man Mose is dead!"

In his later years, my grandfather described these characters and elements of this scene of "Spoons the Minstrel." (My imagination filled in the rest.) It was the childhood recollection he repeated daily to anyone who would listen. To me, it was a sad glimpse into a bittersweet time—a loop of memory locked inside an old nostalgic mind.

The Strawberry Festival was a grand occasion for the Jackson Purchase, attracting farmers, merchants and medicine shows to the area. Archived recordings of Paducah fiddler Charlie H. Hall recount stories of another minstrel/medicine show at the festival, one put on by huckster Joe Bass and his two blackface partners, "Bottle Stopper" and "Popcorn." Various copies of patent medicine pamphlets can still be found in antique stores here, like *Granny*

Metcalfe's Dream Book, which attempted to interpret the visions of gullible local yokels. Bottles of Podolax, Grove's Tasteless Chill Tonic and other snake oil remedies were common in Jackson Purchase households too. But the greatest legacy of the medicine show is its formula of a "free show with advertisements," which continues today on radio, television and the stage of American opry shows. It is the latter that is the subject of this book.

The "Four Rivers Region"

If you take out a map, you will find "The Purchase" in the western lowlands of the Bluegrass State. It's an area with little to no violent crime to speak of, transfixed as she is on her lazy, rolling rivers. She lies utterly cut off from the rest of the state, almost as an island to herself. The Jackson Purchase is so called because the one-and-only Andrew "Old Hickory" Jackson swindled her away from the Chickasaw Indians years ago. The region's nearest kin is the boot-heel of Missouri and a section of southern Illinois known as Little Egypt—two other castoffs from their own home states. The Purchase shares the same line of latitude as Damascus, Yokohama and the Rock of Gibraltar, but there are few topographical highlights here. Well, that's not entirely true. The occasional Appalachian foothill can be seen subsiding slantways into the Mississippi River, where it descends out of sight and forever into the earth's deep mantle.

There truly is a whole other vibe to this part of Kentucky. These eight little counties have a deep connection to their life- and job-giving waterways. Indeed, the world's greatest concentration of navigable rivers is right here. The Ohio, the Tennessee, the Cumberland and the Mighty Mississippi all meet smack dab in this heartland of America. Looking at a map of our nation, it is almost unbelievable how Paducah, the crown jewel of the Jackson Purchase, never became the largest city in the USA.

Imagine if America were a living, squishy organism. Surely Paducah would be its main artery, its aorta—or its very heart-pump. Barge traffic would be its hemoglobin and levees its veins. In fact, the Purchase area seems to almost siphon cultural influence from all directions. Blues flows backward from the Mississippi Delta, and mountain music trickles down the Ohio Valley. In this way, the Purchase is constantly replenishing.

Despite its "red-headed stepchild" status in the eyes of the rest of the Commonwealth, there is much to celebrate here. Not only has the area produced

such household names as Lily Tomlin and Boots Randolph, but residents also enjoy laying claim to Alben "The Veep" Barkley, Irvin S. Cobb and (perhaps just as important) Catherine Bach, TV's Daisy Duke! Other musical celebrities include jazz pianist and bandleader Fate Marable, who gave Louis Armstrong his first gig aboard a paddle-wheeler; Mattie Matlock, a Dixieland clarinetist; and songcatcher Mary Wheeler. More on Wheeler to come.

THE "PURCHASE" OF PADUCAH

The Purchase has but one city with a population over twenty-five thousand: Paducah, the aforementioned economic hub of the Four Rivers Region. The only other two locales large enough to constitute a "city" are Mayfield, in Graves County, and Murray, in Calloway County.

Paducah (originally known as Pekin) was once the domain of the fabled Chickasaw Indian leader Chief Paduke (who may or may not have really existed). Legend has it that he lived in a mud yurt at the mouth of Island Creek, a stream that empties directly into the Ohio. This area was hot property for America's river industry, so in 1827, William Clark (yes, of Lewis and Clark fame) presented Paduke with an "official" title deed to the land the chief called home. Chief Paduke respected this arbitrary piece of paper with dire sincerity. Maybe it was the impressive calligraphy, the excellent penmanship or the fancy filigree. Most likely it was because the document was backed by the full force of the U.S. government and its ruthless army of Indian killers. Paduke knew this was an offer he could not refuse, so he moved on. Far be it from him to cause any trouble. To my knowledge, there is no known curse put upon the area by the Indian chief. No "Mothman," no Sasquatch, no Nessie—just the occasional springtime deluge or summertime drought. In fact, it is fabled that the chief had been contemplating a move to Mississippi anyway. So everybody wins.

Unfortunately, Clark's own account of the naming of the town is much less fanciful. In a letter to his son, he states that Paducah is the name of a tribe: "I expect to go to the mouth of [the] Tennessee the 26th of next month and be absent about two weeks. I have laid out a town there and intend to sell some lots [in] it, the name is Pa-du-cah, once the largest Nation of Indians known in this Country, and now almost forgotten."

Regardless if there really was or wasn't a Chief Paduke, Clark's village soon flourished into a town and from a town to a city. Foundries were formed, a

brick factory constructed and a railroad laid. And, as it turns out, Paducah entrepreneurs found themselves equidistantly positioned between Kentucky's coalfields and Illinois' coal-rich "Little Egypt." This muddy little town was suddenly in the geographical bull's-eye of an industrious new America.

Flash-forward to Prohibition times, and the joint really got jumping, what with its speakeasies and brothels. Shore leave for barge workers would bring a seedy sideline to Paducah's river industry. No doubt whorehouse pianos and slide trombones were heard echoing down the brick streets on some nights of the early twentieth century.

The Depression era saw the rise of the "Chitlin' Circuit," a network of speakeasies, hotels and nightclubs that catered to the marginalized African American community. Paducah's Hotel Metropolitan hosted such jazz, blues and R&B artists as Cab Calloway, Duke Ellington, B.B. King, Ike and Tina Turner and many more. Today, special events occur there throughout the year, and a music festival is currently in the works. More on the Hotel Metropolitan to come.

The Lyricism of Lore

Just like anywhere else in the state, rural life and folklore have exerted influence on the music of the area. Train rhythms and paddle-wheels inform the time signature of many a folk tune. Guitar licks twang like vocal inflections and may even echo the sounds of barnyard mule brays and chicken clucks. Harmonicas wail like eighteen-wheeler air horns and locomotive whistles. Auctioneers at livestock sales, with their trance-inducing "sound that sells," might well be the original "white rappers." Farm implements chugging along to a noise bed of crickets, tree frogs, owls and loons create a music of their own.

The "White Thang," a sort of mystical panther or "wampus cat," is rumored to "sing like a child" in the woods of western Kentucky. Then there's that odd hum from the rivers, a sort of eerie white noise. Perhaps it's the sound of pressure being released from a tectonic crack deep beneath the Mississippi River, issuing from the chasms of the New Madrid fault line as pent-up steam, water, sand and coal grind, gush and groan. Music truly can be heard everywhere in the Jackson Purchase.

AN INTERVIEW WITH NATHAN BLAKE LYNN

I sat down for an interview with musician and archivist for the McCracken County Library Nathan Blake Lynn, the perfect person to voice the history of the region's music. His firsthand experience playing music in the area blends well with his local interest pursuits. When I asked him what makes the Jackson Purchase special, he paused to take the question seriously.

"Well," he said, "it's the rivers."

Nathan believes the waterways are what have brought the different sounds to the region. It is a place of influx from other lands yet isolation from its own state. To illustrate, he pointed to the thousand-year-old cypress groves that stand flooded in the backwaters of our area. They're almost symbolic of our secluded sector of the Commonwealth.

But who cares what the rest of Kentucky thinks. "Fate Marable, the inventor of riverboat jazz, was raised on South Seventh Street in Paducah," Lynn stated with pride.

"Then there are the roustabouts that Mary Wheeler recorded." While all other folk art forms have been tagged, catalogued and done to death, *this*, he declared, is the last collection of untapped American folk music.

"And hell, there's no telling what kind of great music that the native [Americans] who lived here once made…before we ran them off."

I asked Nathan about some of his favorite places to hear and play music. He believes the small gatherings, where barbecue is the main food, are the most important and unique—places where "fellowship is shared from hickory bottom chairs on front porches…or around a fire."

Nathan also believes gospel music is an important component of our area's culture. Indeed, it has a major place in the music that we listen to and play today. The shape note "Big Singing" in Benton is the most notable example of pure gospel traditions.

On the flipside, Lynn is keen to point to the small backwater bars around the Purchase: Jimbo's, The Hilltop, the Silver Bullet… "There's just something about Sunday night drunks [drinking] in the river bottoms that brings a welcomed, sad feeling. It seems to define country music very well to me."

Lynn and I were both schooled by Kentucky blues act the Buster Morrison Blues Band. They played at the now long-defunct Moss Rose Café on Paducah's brick-lined Second Street. "That's where I had my first real bar gig," admitted Lynn. "Of course, I was underage and playing some pretty awful music, but it was dark and lonely. I liked it."

THE SONGCATCHER

Then the subject turned to Mary Wheeler (1892–1979), Lynn's personal heroine and a woman in our region's history about whom he has devoted hours of research.

Sheet music from Mary Wheeler's "Steamboatin' Days," © 1972. *Louisiana State University Press.*

"Mary Wheeler was a Paducah native who studied at the Cincinnati Conservatory of Music. She also traveled overseas with the Red Cross during World War I and entertained the troops. For a time, she lived and taught at the Hindman Settlement School in eastern Kentucky, transcribing the songs of that section of the Appalachian Mountains (see section on Hindman Jams). She published a book of these songs, and more information about her time there can be found at Berea College."

While preparing to work on her thesis, she remembered the roustabout men and women who had worked so hard on the rivers during the packet boat era and the songs that they sang of life on the waters. She set out to interview these men and women who lived along the banks throughout the Jackson Purchase. At the time, there was no available way to electronically record their music, so she made her own field recordings by writing down the words to the songs and then hurrying to her home in downtown Paducah. With the help of her piano, she proceeded to write down the music from memory.

Mary eventually published these songs through the University of Louisiana as *Steamboatin' Days*. She also compiled *Roustabout Songs of the Ohio River Valley*, to which humorist Irvin S. Cobb wrote the introduction.

"She is admirable for many things," Lynn went on. "But most importantly, to me at least, she recognized the importance of documenting these people's stories. She was also humble enough to visit the homes of black roustabouts and ask them to sing for her. She was an upper-class, classically schooled white woman, and to have the courage to head out on her own and randomly approach these fine folks is amazing to me, [especially] in lieu of the state of race relations at the time."

Mary Wheeler is an important figure to Lynn, who himself is drawn to the music of steamboats. He and I are both veteran musicians of the paddle-wheeler circuit; he performed on the *Delta Queen*, and I played on the local excursion boat the *Paducah Jubilee*. As such, Lynn feels strongly that the river-friendly Wheeler deserves more credit in the history books than she gets. Maybe this book can help change that.

BACK TO THE BARN

As a historian of the area, Lynn clued me in on a few names of note from Jackson Purchase's history.

"'Blind' Joe Mangrum was one of the first *Grand Ole Opry* stars." He was born in Weakley County, Tennessee, but he spent much of his life in western Kentucky. Joe was well acquainted with traditional western Kentucky/Tennessee fiddle tunes, but he enjoyed playing classical music as well. Legend has it that this is the reason he did not continue to perform on the *Grand Ole Opry*.

There were a number of string bands based out of Paducah around the turn of the nineteenth century. Charlie Hall fiddled at the local medicine shows. Frank Jones String Band was very well respected and played at barbecues, picnics and steamboat excursions. His group featured the well-known one-eyed, one-legged fiddler Ed Ewens, aka the "King of the Waters."

Lynn's short list of area favorites includes the following: "'Rockin' Ray Smith, Whitey 'The Duke of Paducah' Ford, Chris Thile, Stanley Walker and Josh Williams." Local boy and "chicken catcher" Kevin Skinner "done good" when he claimed first place on NBC's *America's Got Talent*, netting himself a Vegas gig and a record contract. Gospel megastar Stephen Curtis Chapman is from Paducah, as is Larry Stuart from the band Restless Heart.

Today, live music plays all summer long in Paducah. The "After Dinner" concert series hosts buskers along Broadway when weather permits. Five to six city blocks are coned off, allowing pedestrians to get up close and personal with the singers, shops and tourist traps. Pickers like Lonzo Pennington and Nathan's group Bawn in the Mash are known to play both this event and the popular summertime cook-off "Barbeque on the River." These Paducah fests have come to replace the Strawberry Festival of yore.

Elsewhere in the Purchase, Fulton, Kentucky, has a banana festival and Marshall County observes the solemn occasion known as Tater Day. There is the Big Singing in Benton, Kentucky, every year, where southern harmony gospel singers gather to line out the old "shape note" hymns. It is, as Lynn describes, "one of the closest things to American 'monk chanting' you can find."

Kenlake State Park has the Hot August Blues and Barbeque Festival in Aurora, an event where your author had the privilege to witness such old-school blues singers as Junior Wells, Snooky Pryor, Clarence "Gatemouth" Brown, "Honeyboy" Edwards and R.L. Burnside, many of whom were veterans of both the Chitlin' Circuit and the medicine show's Kerosene Circuit.

Delta blues meets hillbilly music meets R&B meets honky-tonk. Every strain of American musical influence blends together in the land of the redheaded stepchild. Is it any wonder why rock 'n' roll originated in a similar area just south of here in Memphis, Tennessee? Cross-cultural dynamics like these are what make the Jackson Purchase and, in my opinion, the entire

South a bastion of music, culture and cuisine—all of which are secretly the envy of the world.

> ## EARL BUTLER'S "YOU-CAN-BE-A-STAR"
> ### OLIVE, MARSHALL COUNTY
> ### SATURDAYS, 6:00–9:00 P.M.

The lonely country road twists and turns through a patch of western Kentucky that strangely looks like a holler from the eastern end of the state. Marshall County's terrain is the hilliest of this westernmost "Jackson Purchase" region.

Blink and you'll miss the rusted, blown-out marquee, overgrown with weeds and missing a few letters. There are only enough characters to guess the name "EARL" and the words "COUNTRY MUSIC." This is where you turn.

The gravel path leads past the tattered tarpaulin of an old deer stand. It whips in the wind toward a woodland shack made from corrugated tin and random planks. The foreboding woods that encircle may seem like the domain of hoop snakes and wampus cats, but be not afraid. A friendly wooden Tennessee Walking Horse marks the entrance. And if you listen close, the vague sound of an Ernest Tubb tune pulses from the cracks, inviting you in.

It's as dark as a dungeon inside, and smoke hangs above the tables of chatting wives and fidgety children. A "Wall of Fame" features dog-eared 8x10 glossies of Nashville stars, Polaroids of friends and family, blue ribbons, trophies and a novelty document that serves as a "Certificate of Upgrade to Complete Assh*le."

Two-by-fours hold up the roof, which has started to sag in spots. In fact, certain panels of the ceiling bow as low as five feet. Butler laid the foundation himself, pouring the concrete without the use of any forms. The floor must have dried into place at an angle because there's an off-center "fun house" feel to the whole room. Onstage, the menfolk are seated, playing honky-tonk classics in the golden glow of homemade, coffee-can stage lights. The bandstand is bedecked with Hank Williams show bills, vintage tube amplifiers and guitar-shaped decorations. To me, it's like the white man's version of a Mississippi juke joint. Earl Butler leads the group, while regulars like "Hillbilly" Bob Prather accompany. It's been this way for over twenty-five years.

Prather, a veteran musician from the old *Louisiana Hayride* radio show, and his wife, "Granny," will perform their own original material mid-set. He is a wealth of knowledge about the old-time fiddle music of western Kentucky. Tunes like "Mayfield," "Thump the Devil's Eyes Out" and other obscure old gems flow effortlessly from his bow. His grandfather fought in the War Between the States; therefore, many of the oldest American ballads were passed down to him firsthand. Prather's hillbilly and Cajun tunes have even been archived by Berea College, with the help of Layne Hendrickson, another regular at Earl's pickin' party.

When asked about pickin' parties in the days before television, Prather described the scene from his daddy's front porch. Folks would carve jack-o'-lanterns for a light source so they could dance in the dark. The pickers set up on the porch as if it were a stage facing outward to the yard, and the people would dance there until dawn.

Unlike today, when the old-time and bluegrass communities have adopted exclusionary policies, anyone back in Prather's day could play in the band. In fact, any warm body that could make a noise with an inanimate object was encouraged to join in. If tapping a mason jar on a table or rhythmically

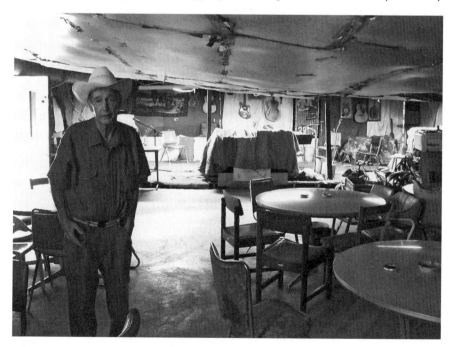

Earl Butler inside his Olive jamboree building. *Photo by the author.*

sweeping a broom provided the right percussion, it was encouraged. There were no rules yet in folk music. In fact, it was just called *music*. The same spirit survives today on Butler's stage.

I asked Earl about all the famous folks he's played with over his many years in showbiz. He responded with a slow, twangy list: "Carl Butler...Carl Perkins...Hank Junior...Stanley Walker," Butler remembers each name between long pulls from the amber filter of his cigarillo. The shadow cast by a cowboy hat hides his eyes, but a glowing ember illuminates his face with each drag. He is decked out in a powder blue polyester cowboy ensemble— sort of like a piece-meal Manuel suit. A white belt with musical notes strings through the loops. His cowboy boots scuff the uneven concrete floor as he moseys back to the concession stand.

The genre showcased here at Earl's is mostly old rockabilly (common to western Kentucky, due to the influence of the bluesy river culture) and honky-tonk, with material ranging from Johnny Cash to Dwight Yoakam. Anyone is welcome to get up and sing a song once the show is off to a good start. Back by the vintage icebox, Cokes, coffee and candy bars are available for snacks (and maybe even some of Prather's homemade wine...if you're lucky). Dubbed-off cassette tapes and CDs of the music sit in a shoebox. They're three bucks each.

Come 9:00 p.m., the show always ends with Earl's grandkids taking to the stage to sing "Crawdad Hole." Then, one by one, the pickup trucks roll out into the night as the music still echoes in the holler.

Heading east from the Benton town square on KY 408, drive 1.5 miles to Hamlett Church/Olive Rd (1897) and turn right. Drive 1.5 miles down and turn left onto Abraham Road. Earl's place is on the right at the bottom of the hill. Stop in and tell 'em I sent ya.

After all, you could be a star!

CLAY CAMPBELL'S KENTUCKY OPRY
DRAFFENVILLE, MARSHALL COUNTY
NIGHTLY SHOWS AND JAMS

Clay Campbell, the multitalented entrepreneur behind Draffenville's Kentucky Opry, has given his community many things over the years. Big-name country entertainers (Marty Stuart and Connie Smith) and top-notch weekly productions are always on the books. Perhaps more importantly,

Campbell has long fostered a steady stream of fresh young talent aboard his famous nightly stage. Why, even yours truly played a teen talent contest alongside Campbell and his country comedian sidekick Scottie Henson.

Henson is the area's most invaluable banjo mentor. When he's not fetching the eggs out of his chicken coop, he's teaching five-string banjo to youngsters in his cabin, playing the Opry or starring in the new *Woodshop* television series.

As a young picker, Scottie only jammed occasionally with local guitarists Merle Sturgill, Frank Pascal and the fiddlin' preacher "Peg" Basil. They were a string band that played on a WNBS radio jamboree in Murray, Kentucky. But when local fiddler David Myers encouraged Scottie to step out more, Henson was reluctant (after all, he had just taught himself by slowing down a Flatt and Scruggs album and down-tuning his banjo). However, Henson persevered and eventually got to be the professional he is today. In 1960, he met the great Earl Scruggs at a local schoolhouse concert. That's when Scottie received a personal invitation to visit Scruggs at his Madison, Tennessee home—but not before gleaning a few pointers from the banjo master himself.

"He told me 'the easy way is the right way,'" Henson recalls of Scruggs. Scottie has since made a living passing along similar wit and wisdom to new generations of musicians. He has developed his own unique style of tablature (a sort of musical notation) to help teach bluegrass-style banjo. In fact, his musical shorthand is so easy to comprehend that Mel Bay was interested in publishing it. Unfortunately, Mr. Henson recently suffered a neurological episode similar to a stroke, greatly limiting his abilities. But miracle of miracles, the affliction has left his right hand frozen into the perfect "clawhammer" position, thus enabling him to keep his students and continue playing. The Lord works in mysterious ways!

There must be something in the water to produce so much special talent in Marshall County—musical whiz kids too. From a young Chris Thile (mandolinist for Nickel Creek and the Punch Brothers) to Josh Williams (guitarist for Rhonda Vincent and banjo player for his own High Gear Band), Clay Campbell has hosted them all. New blood like teenage banjo genius (and Henson alum) Aaron Thompson, plus Campbell's own sons, Clayton, Cody and Casey, are starting to take off too. Be sure to see the Opry's "Stars of Tomorrow" showcase on Friday nights.

I, and any upstart musician worth his salt in the Jackson Purchase, had to cut his teeth on the Kentucky Opry stage. Campbell's teen talent contests were for me (and are for others) a great way to "get in the game." It is truly important for young musicians to get that full band experience early on.

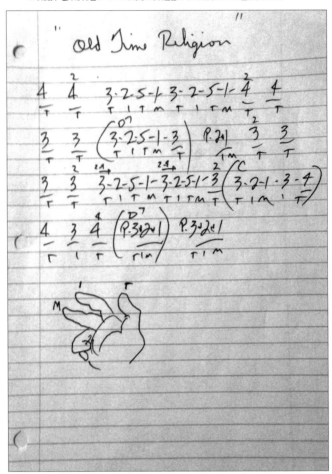

Scottie Henson's hand-drawn tablature. *Photo by the author.*

By the way, no, I didn't win the talent contest. My harmonica rendition of "Pride and Joy" (complete with Campbell's bespectacled Buddy Holly impression going on behind my back) just couldn't cut it. The needle on the applause-o-meter barely wiggled. In fact, I believe I was beaten by the aforementioned Josh Williams. Yes, my humble "fist whistle" stood no chance against his lightning-fast, "high gear" banjo. It was like trying to storm the beach of Normandy with a peashooter.

The Opry touts a twelve-member cast of singers, comedians, guest entertainers and musicians ready to provide you a rollicking night of "clean, family entertainment" and a welcome break from the crude entertainment of our modern times.

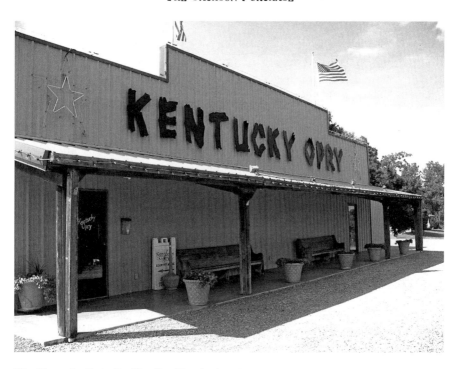

The Kentucky Opry, Draffenville. *Photo by the author.*

Clay Campbell's talent shows, monthly bluegrass jams, comedy nights and opry-style concerts with big-name celebrities run constantly and prove that the Jackson Purchase has just as much to offer the country music scene as anywhere else. After all, Clay Campbell's Kentucky Opry has been dubbed the second home to many of the stars of the *Grand Ole Opry*. Not too shabby! Visit www.kyopry.com for directions and details.

> ### Tadpole's Dew Drop Inn
> Possum Trot, Marshall County
> Wednesdays, 7:00–9:00 p.m.

With a name like "Possum Trot, Kentucky," you would hope the town would have a decent hillbilly music scene. Rest assured, that can be found in abundance at Tadpole's Dew Drop Inn.

Larry Madden, aka "Tadpole," has been hosting this show since 1982, making it the longest-running musical shindig in the Jackson Purchase.

The tidy, pre-fab metal building sits in back of his house off Calvert City Road. Every Wednesday night, the gravel lot fills with the cars and trucks of country music fans, pickers and dancers (although dancing is supposedly illegal in Marshall County).

While Tadpole rarely plays (his talent is belied by modesty and self-deprecating humor), his band is one of the tightest I've ever heard. Emphasizing honky-tonk hits from the '50s through the '70s, these guys know the country music canon like the backs of their hands.

Rows of folding chairs face a wide stage that holds a beat-up barrelhouse piano that's been painted barn red. Colored floodlights bathe the bandstand in a moody ambiance. Framed western scenes and a portrait of Mr. Tadpole himself help pretty up the place.

In the back of the room, there's coffee to drink and tables for the kids to sit at and color with the Crayolas Tadpole has been kind enough to provide. There's always a capacity crowd of mostly folks old enough to remember the halcyon years of classic country music. But more and more, the younger generation is discovering this cultural treasure. This is made evident by young Eddie Dunlap, a master of the steel guitar, who has recorded for Hank Williams III. There is also the occasional young lady or two who will take the stage to belt out the classics. And believe you me, they are every bit as good as the finest talent you can find in Nashville, Tennessee. No "auto-tune" gadgetry required.

Heading east out of Paducah on U.S. 62/Kentucky Dam Road, drive four miles and turn left onto Calvert City Road. It's down on the left. If you're a sucker for souvenirs like I am, be sure to get a Possum Trot, Kentucky T-shirt at the IGA or at the BP "Possum Mart."

DUCK CREEK GENERAL STORE
PADUCAH, McCRACKEN COUNTY
OPEN YEAR ROUND

Duck Creek RV Park might be the most unlikely place to find a most unlikely jam on the most unlikely instrument. From time to time, an assembly of *psaltery* enthusiasts gathers in the general store to play the instrument made famous by the one and only King David (of the *Bible*, that is). It seems an unlikely backdrop for such heavenly music, what with all the shelves of camping supplies, snacks, tackle and bait. Regardless, you will be transported to an otherworldly realm upon your first listen.

The psaltery, like the bowed dulcimer, is an ancient instrument whose sound has brought peace and comfort to Duck Creek's wheelchair-bound owner, Mike Vessels. After suffering the effects of multiple sclerosis, Vessels was left unable to play his first instrument, the piano. However, he soon discovered a love for the healing sounds of the psaltery. Having mastered the instrument, he plays with his group every so often when the feeling is right. I once had the honor of giving Mike a lesson on harmonica, a very different kind of "harp." In exchange, he showed me how to play the psaltery. It was a nice trade.

Although Mr. Vessels has slowed down since my first visit/harp lesson, the music plays on. He has handed over most of the daily RV park dealings to manager Karen Brinkman, who keeps the tradition going. Brinkman even demonstrated her skills during my second visit to Duck Creek. It sounded as glorious as ever.

To hear the magic for yourself, and perhaps purchase a psaltery of your own (they sell them in the general store), visit Duck Creek RV Park, Exit 11 on John Puryear Drive in Paducah.

GRAND RIVERS COMMUNITY CENTER
GRAND RIVERS, LIVINGSTON COUNTY
FRIDAY NIGHTS, 7:00–10:00 P.M.

Within the cavernous halls of the Grand Rivers Community Center, couples of all ages two-step and swing to the sounds of Mr. Stanley Walker, the greatest musical living legend in the Jackson Purchase. It's as if all the dancers from neighboring Marshall County (where dancing is against the law) have been set free to go do their thing.

Mr. Walker is famous for having recorded for Sam Phillips's Sun Records in the '50s and '60s (think: the glory days of Elvis Presley, Roy Orbison and Johnny Cash), backing rockabilly legend and Paducah native "Rockin'" Ray Smith. He has also played the *Grand Ole Opry* many, many times, acting as the musical director for Opry member Jean Shepard. What's more, he's even jammed with Jerry Lee Lewis a time or two.

All of these accomplishments have won him an induction into the Rockabilly Hall of Fame, located in Jackson, Tennessee. Another hotshot known to sit in at the center is Howard Walker (no relation), who is an excellent pedal steel player.

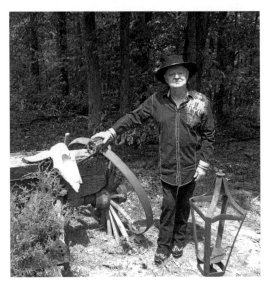

Stanley Walker outside his home in Grand Rivers.
Photo by the author.

While in Grand Rivers, be sure to check out the Badgett Playhouse, Patti's restaurant (and petting zoo), the Pelican and all the other great activities Kentucky Lake offers. Just remember, Stanley Walker is just as much a natural treasure as anything else here. See him while you still can. (More on Walker to come…)

The Community Center is located at 155 West Cumberland Avenue, one block west of J.H. O'Bryan and behind First Kentucky Bank. Feel free to call ahead at (270) 362-8976.

BADGETT PLAYHOUSE THEATRE AND "STANLEY WALKER DAY"
GRAND RIVERS, LIVINGSTON COUNTY

This six-thousand-square-foot facility serves as the home of VARIETY! Music, Memories and More, a Branson Missouri–style revue of popular music and dancing from the 1940s swing era to the Motown movement of the 1960s. Elaborate costumes and dance routines are featured during this tribute to American music. The talent is top notch, rivaling the best from Nashville or even Broadway.

Every year, the Playhouse also honors Grand Rivers' most famous resident, the aforementioned Stanley Walker, with "Stanley Walker Day". The event raises money for the Kosair Hospital in Louisville, Kentucky, and recently celebrated its fifth year. The hospital is a cause very near to Walker's heart, as he was a Kosair patient in 1948. "They saved my life," he said. The seventy-four-year-old guitarist is the hospital's most prominent spokesman. He was recently featured on both its billboard in Louisville and a Paducah-area TV commercial.

As the recipient of good karma, Mr. Walker was recently inducted into the Rockabilly Hall of Fame in Jackson, Tennessee. His years as a regular on the *Grand Ole Opry* and at Sun Studios have really paid off, but when I sat down with Walker to talk, I got a lot more information about his life prior to fame.

"I came up through the rough times," Walker explained, citing hard times in the Twin Lakes area. "I played 'between the rivers' at the old schoolhouses. I was young, just a kid playing with some real old-timers. It was Jack Penniger on fiddle and mandolin. Oved Trim was on guitar and did the singin'. Wilburn Walker played the bass fiddle and was the comedian."

Walker takes issue with the notion that eastern Kentucky corners the market on old-time traditions and hardship: "Buddy, I was in on it. When those old battery radios were sittin' in the windows listenin' to the *Opry*. When there was just gravel roads and no blacktop. When the ferry ran from Kuttawa. I was there!"

Walker described a square dance that was once in Grand Rivers, Kentucky. "Years ago there used to be [one] at the Iron Kettle [in Grand Rivers]. And Jack Green called one in Eddyville on the street in front of the courthouse. I still play there on Founders Day."

As a young man, Stanley and his band had their own show on WCBL, the radio station in Benton, Kentucky. "Boy, we thought we were big stars! We played on WPKY in Princeton, too." Walker also served as the guitarist in the Carl Barber Band, an all-black group in Paducah that performed American standards at the 400 Club, behind the jailhouse.

"[My group] played a street dance in front of the Kentucky State Penitentiary. It was just a little show we put on, playing good ole country music." Years later, Stanley would approach Sun Records recording star "Rockin'" Ray Smith of Melber, Kentucky, at an Illinois "play party." "The show was over, and they were tearing down the gear. But I asked if I could show them how I play." Stanley had developed a unique finger-picking style after studying local guitarist Happy Parrish.

Suffice it to say, Smith was so knocked out by Walker's way of playing that he hired him. The blend of Smith's rock 'n' roll sound with Walker's finger-picked guitar helped further define the budding new rockabilly genre of the 1950s.

Although Stanley currently suffers from diabetes, it hasn't slowed him down. In addition to his yearly preparations for "Stanley Walker Day", he plays every Friday night at the Grand Rivers Community Center and has done so for the past thirteen years. He'll also be hosting a talk at the

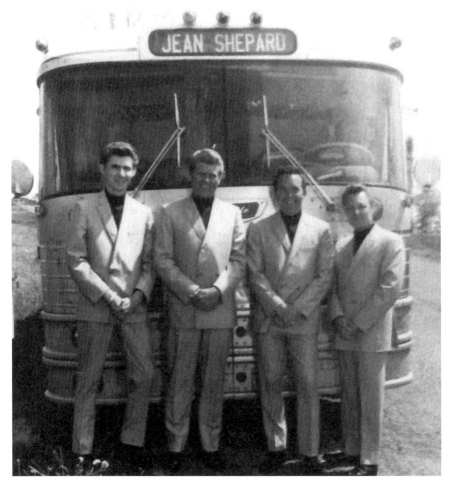

Stanley Walker (far right) on the road with Jean Shepard in 1960. *Stanley Walker collection.*

library regarding his old band mate Ray Smith. It is this association with Smith that has won him the most worldwide notoriety. Bear Family Records, of Germany, re-releases classic American music, much of which is old rockabilly. These remastered CDs have spawned a new generation of fans for a genre that Walker helped create.

"That Bear Records exec told me, 'Stanley, you got fans you don't even know about!' I get mail from Sweden and all over. And I just about cry when I receive a letter like that."

When I asked him about the state of modern country music, Stanley had a very wise and measured response: "My heart is in pure country music. And

it's a shame that Merle Haggard can't get played on the major stations. But it's the young kids' time, and it's their music. We had our kind of country and rock, like Johnny Cash, and now they've got [theirs]."

Walker continued, "But I always wondered why all the sidemen in Nashville didn't get recognized. They've got God-given talent, a family and yet they don't get recognized." He mentioned names like Luther Perkins, Leon Rhodes and James Burton, sidemen eclipsed by their famous front men. However, Walker admits, "I never wanted to sing; I just wanted to back someone up and play licks." There's nothing wrong with that, I say, and it's definitely not a bad way to make a living.

However, after his regularly paying house gig in Paducah dried up, Stanley had to go to work for the road department for a few years, driving trucks, running an end-loader, mowing grass and anything else to pay the bills. Thankfully, he's back onstage and finally receiving the recognition he deserves.

"I'm not a big name," Walker admitted, "but I've had a good career and [it] means a lot to me. They say, 'Stanley, your music will live on long after you're gone.' And it just touches my heart more than you'll ever know."

Be sure to call ahead to plan your pilgrimage to see the western Kentucky rockabilly legend. "Stanley Walker Day" occurs every May, and all proceeds go to a great cause. "Every nickel of it!" Walker promises.

Contact organizers at (888) 362-4223. Take I-24 to KY Exit #31. Go south on 453 toward Grand Rivers (three miles) and then left on Commerce. The theater is at the corner of J.H. O'Bryan Avenue and Commerce.

HOTEL METROPOLITAN
PADUCAH, McCRACKEN COUNTY
SEASONAL SPECIAL EVENTS
FIRST FRIDAY FISH FRIES, 11:00 A.M.

In my introduction to this chapter, I made mention of Paducah's famed Hotel Metropolitan. While it may not perfectly embody the format of a barn dance or jam, it definitely deserves mention in this work. After all, the place has definitely seen its fair share of jamming.

The hotel, once a stop along the African American touring route known as the Chitlin' Circuit, stands today as a revitalized venue for special events. These events celebrate the blues and R&B of America's black culture,

styles that have indisputably influenced the country music of white folks too. One listen to Elvis Presley, Charlie Rich and Jerry Lee Lewis will verify this claim.

Built in 1909 by twenty-four-year-old Maggie M. Steed, the hotel was destined to become a hit. Steed had seen a need for a Paducah-area "colored" hotel. As we all know, dark-skinned people continued to be intensely marginalized in the days following slavery, forbidden even to window-shop at clothing stores. So Maggie got to work, using her husband's name to secure a deal with a lumber company that owned the property. By 1915, the stately Victorian hotel was so valued as a haven for black travelers that word began to spread around the country. As such, it would soon become the heart of an African American community that extended far beyond humble McCracken County.

After Steed's death in 1924, Edward and Lucille Wright assumed ownership but passed it along four years later to Henry Gause and Mayme Gause Burbridge. These two would oversee the rise of the jazz age from one of the best possible vantage points. Riverboat talent agent Fate Marable, a resident of Paducah, invited many now-famous icons to the area. Musicians like Cab Calloway, Count Basie, Duke Ellington, Baby Dodds, Ella Fitzgerald, Billie Holliday and Louis Armstrong have all stayed at the Met, often jamming into the night. Imagine the sounds that could be heard on a Saturday night during this remarkable era!

During the 1950s, Lester and Olivia Gaines, who managed the hotel, housed members of Negro League baseball teams and the Harlem Globetrotters. But rockers like Ike and Tina Turner, Chuck Berry, Little Richard and Ray Charles still stopped by. Even B.B. King was given to play his trademark guitar "Lucille" on the front porch. The presence of these "creative types" didn't stop Baptist conventioneers from following suit. Athlete Jesse Owen and even Supreme Court justice Thurgood Marshall famously graced these hallowed halls as well!

When segregation ended in the 1960s, the hotel shifted its focus away from the diminishing Chitlin' Circuit and became a humble rooming house. It wasn't long after that the hotel fell into decline. Unkempt and abandoned, the place descended into ruin while the "black America" it once represented struggled to integrate into white society.

After a recent push to revive this landmark, the Hotel Metropolitan has slowly become relevant again. Today, it is the backdrop for many special occasions throughout the year. A fish fry is held on the first Friday of every month at 11:00 a.m. Salute(s) to Black Music and Emancipation Celebrations

are held there now. Whispers of an annual music festival are also aloft. Consult the Hotel Metropolitan website (www.thehotelmetropolitan.org) or call Betty Dobson at (270) 443-7918 to plan your journey to this haven of history, music and culture.

Visit in person at 724 Jackson Street, Paducah, Kentucky.

WESTERN KENTUCKY

THE "BLACK PATCH"

The western Kentucky region, known as the "Black Patch" (which also includes some of the western coal field, Jackson Purchase and westernmost Mississippi Plateau), is literally some of the most fertile ground in Kentucky. The rich nutrients of an ancient ocean bed mix with the silt and limestone of our Appalachian foothills, creating an ideal farmland ripe for the plow. Tobacco flows in fields of umber waves while dark-fire burley barns smolder along backcountry roads. The crop is both integral to and synonymous with western Kentucky, and business boomed back in the heyday of stogies and chaw. But during the early twentieth century, battles over union loyalty were waged between farmers. A war broke out during a period when North Carolina's Duke Tobacco trust was driving prices down to new lows. Some Kentuckians donned feed sack masks and rode as "Night Riders" through the drear. Family members turned on one another, much as they had during the last civil conflict of the 1860s. In fact, the longest and bloodiest American conflict to occur since the Civil War was this so-called Black Patch War (1904–09).

One wonders if the ultra-melodic tones of the area's indigenous "Travis-style" guitar were devised as a form of post-traumatic self-therapy. As they say, music hath charm to soothe the savage breast/beast, and western Kentucky has had its share of shellshock. Therefore, it is little wonder why so much talent and creativity, from John Prine to Merle Travis, Ike Everly to

Bill Monroe (even Robert Penn Warren and psychic Edgar Cayce, for that matter), sprung from such a troubled region. Perhaps they are expressions of their homeland's own healing process.

The year 1944 saw the damming of the Tennessee and Cumberland Rivers. Like many places in FDR's America, Kentucky's western rivers were flooded to create a hydroelectric power source. Our Kentucky and Barkley Lakes would form the largest man-made American lake system east of the Mississippi. The sliver of land between the two bodies of water was preserved as a national park and a place of beauty. If you come for a visit, keep an ear out for the faraway tones of Park Ranger Jonathan Ferrell's frailing banjo. It echoes through the woods from his work at the Homeplace, a working history farm just outside the Kentucky border in Tennessee. The Pickin' Party at the Homeplace is held each June. You're sure to enjoy the music and all the handicrafts displayed by Ferrell, who is an expert blacksmith, Civil War reenactor, storyteller, folklorist, furniture maker, log cabin builder, fiddler, banjo player and just about anything else you can think of. He truly belongs in a museum all his own.

THE FATHER OF BLUEGRASS MUSIC

Speaking of museums, the International Bluegrass Music Museum in Owensboro hosts a bluegrass jam each first Thursday of the month. The museum honors the achievements of Bill Monroe (1911–1996) and his Blue Grass Boys, originators of the bluegrass genre. The place came into existence in the 1980s, when it finally dawned on everybody that this popular style of music was distinct from the regular country music of, say, Kenny Rogers. Indeed it is, and thusly deserving of its own museum. Actually, given today's "New Country" sound, the two genres couldn't be any more diametrically opposed. While Nashville's latest "hat act" is grinding out trendy cookie-cutter chartbusters (no doubt written by a committee of "white flight" yuppies fresh from LA), western Kentucky rests assured knowing that it is the *true* birthplace of country music's most earnest offshoot.

In fact, no other segment of the state has made as huge a musical impact on the world as the western region. Bill Monroe benefited from the river-borne traffic of jazz and blues traditions, like those embodied by his African American mentor, Arnie Shultz. Had it not been for this infusion, bluegrass would have far less of its "blue note" soul. Therefore, it stands

46

to reason that the world beyond Kentucky would not have paid as much attention. Likewise, Mose Rager (1911–1986) would not have articulated the barrelhouse piano rolls on his "finger-picked" guitar without Shultz's "up from New Orleans" influence. While it is true that old-time mountain music has always contained rhythmic and melodic elements of African American influence, the extra emphasis Monroe placed on "the blues" is perhaps what made bluegrass more accessible to the masses.

As Monroe recounts in James Rooney's book *Bossmen: Bill Monroe & Muddy Waters*:

> *The first time I think I ever seen Arnold Schultz* [sic]*...this square dance was at Rosine, Kentucky, and Arnold and two more colored fellows came up there and played for the dance. They had a guitar, banjo, and fiddle. He lived in a little mining town—I believe it was called McHenry—or on down further. There's things in my music, you know, that come from Arnold Schultz* [sic]*—runs that I use in a lot of my music. Me and him played for a dance there one night and he played fiddle and we started at sundown and the next morning at daylight we was still playing music—all night long. I believe if there's ever an old gentleman that passed away and is resting in peace, it was Arnold Schultz* [sic]*—I really believe that.*

Western Kentucky's preeminent jamboree is in a barn in Rosine. Any traveler truly interested in using this book for ideas must attend the long-running Rosine Barn Jamboree. Hardly a better example of the subject can be found.

ROSINE BARN JAMBOREE
ROSINE, OHIO COUNTY
FRIDAY NIGHT JAMBOREE

Without its bronze placard of Bill Monroe and old-timey signage, the old Rosine barn would otherwise sit in obscurity. In fact, if you tend to speed you might just blow past this true mecca of American bluegrass music. Slow down and pull on in, snap a few pictures and sit a spell. The locals here are friendly and love talking about that local boy who "done good."

Under the big tin roof, music fans the county, state and world over have gathered to carry on the legacy of the "Father of Bluegrass." Visually, the

place is the quintessential barn dance, complete with kitschy decor and drafty timbers. The warped wooden stage sits low and faces out to rows of folding chairs and smiling faces. Exposed timbers and studs are mostly left unadorned, although a strand of Christmas lights dangles above the heads of the band members. The occasional hand-painted sign or framed picture of Monroe hangs from a rusty nail or two. At the side-stage concession stand, there's enough popcorn and Cokes to fuel some two-stepping or clogging on the dirt floor. Band CDs are only five dollars, and bottles of water are a buck.

As one might expect, bluegrass is indeed the genre of choice. And, rest assured, the talent inside is simply awesome. Pickers like Grampa Jones' great-nephew Phillip Steinmetz or the young J.T. Oglesby, a world-champion "Travis-style" guitarist, can be spotted performing on occasion. Old-timers too. And it's the *cool* kind of old-timers who still wear flannel shirts, overalls, beat-up cowboy hats and porkpie fedoras. These people really know what the music is all about; you can just see it in their faces. Hard lives of work and farming are etched across their brows and calloused on the skin of their hands. Though tanned and scarred, these pickers can really go to town on a number like "Footprints in the Snow" or "Wheel Hoss." After all, it takes the very best to fairly represent the legacy of the Great Bill Monroe.

Next door to the Rosine barn is Woolsey's. It was once a general store but now intermittently opens to serve as a lunch spot. Shelves that formerly held groceries are cluttered with random goods, and the walls are adorned with folksy, hand-painted art. Musicians often spill over from the barn after the jamboree and pick on the porch, so it's a great spot for mingling. During one visit, my buddy Nathan Blake Lynn and I joined an impromptu pickin' session at Woolsey's. While some jam circles tend to constrict or "close ranks" to exclude outsiders, we managed to finagle our way in and pick a tune or two. They were tough, but luckily, we won them over. Strict musicianship is the first order of business in Rosine, Kentucky. Amateurs be warned!

Tours of Monroe's newly renovated Homeplace, in nearby Jerusalem Ridge, are given 9:00 a.m. to 5:00 p.m., Monday through Saturday, during the summer months and 9:00 a.m. to 4:00 p.m. during winter months. Sundays it is open 1:00 p.m. to 5:00 p.m. (or to 4:00 p.m. in the winter months). Admission is free.

The jamboree is located at 6210 U.S. 62 East, just eight miles east of Beaver Dam in Rosine, Kentucky. Dance or perform if you wish, or bring a lawn chair on summer nights to listen under the stars.

WILDWOOD FLOWER SQUARE DANCE
MAGAN, OHIO COUNTY
MOST SATURDAYS (PHONE AHEAD)

Not far from Bill Monroe's Homeplace is the best little secret in Ohio County and, in my humble opinion, one of the best-kept treasures in all of Kentucky. In fact, there wasn't one detail about my visit to the Wildwood Flower square dance that wasn't timeless and oddly dreamlike. Even the circuitous journey to Magan was glorious and fun, as it took me through multiple quaint small towns and farms. Past several rolling hills and forests I wove, only to take a hard left at an ironically burned-down fire station. Soon I was scratchin' gravel down a clump road that cut through an enormous cornfield. I bumped over the seams of Sulphur Run Bridge as the setting sun bathed the farmland in amber. I took a long, deep breath and tried to appreciate every iota of this moment. This was truly Kentucky at its best.

Honestly, had it not been for the kind lady who had given me directions over the phone, I would have never found it. In fact, only Earl's You-Can-Be-A-Star and the Carcassonne Square Dance are as far-flung as the Wildwood Flower. But I knew I had arrived as soon as I rounded that final half mile into what seemed to be an old ghost town. It's true. Magan could easily be the backdrop for *Little House on the Prairie*, as it once was a stagecoach stop between Hallsville and Morgantown, Kentucky. Founded by Joshua Magan in the nineteenth century, the village formerly boasted its own school, tobacco warehouse and blacksmith forge. It never had its own post office, oddly enough and, as a result, is not on any map.

Despite a few dilapidated buildings, the town is truly filled with life and music. Former sheriff Elvis Doolin has made sure of that. His red and white general store sits astride a green hill, waving Old Glory and looking like a Mississippi paddle-wheeler run aground. That's where I saw the band of old-timers loading in. I could tell this was going to be good.

Elvis and several of his eleven siblings help run this former-general-store-turned-square-dance-hall. The place was built in the early 1900s, but Doolin added on two extra wings in the early 1980s. This allows accommodation for the scores of folks who dance here. Although I was an outsider, I was immediately met with smiles and enthusiasm. The people were friendly, and the space inside was everything you could hope for. Red hand-lettered signage above the stage popped against the stark white

walls. "Welcome to the Wildwood Flower!!" it heralded. Feed sacks and flags, antique tobacco advertisements and framed scenes of American Indians ran from corner to corner.

The musicians set up under an overhang that forms a makeshift band shell. No one in the group looked to be under seventy years old, but the dancers ranged from ten to ninety. (It must be mentioned that a fair number of young people attend this event. Teenagers and college students show up in greater numbers than I would have expected. This is an encouraging sign. Events like this may well last into the future yet.)

The Doolin family have been putting on a family-friendly square dance here for the past twenty years, always packing the place with folks who love good music, live dancing, home cooking and a fair value. "Everybody comes to have a good time," Elvis told me. "For four dollars you can get a show, have a dance, get you a hamburger and a Coke...where else can you do that?"

Elvis not only runs the show, he's the square dance caller too. "I learned by going and listening to the old dances," he said. "I like to call the 'Ocean Wave,' the 'Right Hand Across,' the 'Elbow Swing' and the 'Figure Five.'"

I also witnessed something called a "Broom Dance," which Elvis says is like a "Whistle Dance." "One of the dancers has a broom. When they throw it down, that's a cue to change partners." A "Whistle Dance" uses a whistle to make the cue. When I asked him what the difference is between his square dance and, say, a contra dance, he said he'd never heard of a contra dance. One passerby overheard my question and said she had been to a contra dance in the city but that it contained a lot more "swinging around."

Mr. Doolin, who looks to be in his forties, took his place center stage with his band. He smacked his pair of spoons together to get the rhythm going. That's when Bobby Robinson and Floyd Stewart jumped in on guitar, Martin Cecil picked the mandolin, Butch Edge slapped the doghouse bass and John Lanham sawed the fiddle. Mr. Lanham is somewhat of a legend in these parts, as he is carrying on a tradition set by his grandfather and his father, Lawrence Lanham, author of the local tune "Whistlin' Rufus." John's grandfather and grandson bookend five generations of Ohio County fiddlers. I felt honored when Doolin invited me to sit in on banjo. This would be my first time playing a square dance.

The dance floor filled to capacity with all ages and skill sets. The band was tight, especially with Butch Edge smacking out time on an entirely acoustic bass. I was mesmerized by the hypnotic rhythms of the old-time tunes, scooting boots, rustling bodies and murmured conversations. Somebody's

shoes even came equipped with metal taps on the heels, combining with the rest to create a beautiful cacophony of community spirit. I tell you what: I loved every minute of it.

Hours later, as the band wound down, I was treated to some free hamburgers for my journey home. Elvis's sisters Crecia Brown and Charlotte Owens could not have been nicer. Mr. Doolin has even given me his blessing to spread the word about the Wildwood Flower (he asked me if I know anybody at KET, Kentucky's public television network). Therefore, he and I encourage everyone to visit the sleepy little town of Magan—a ghost town with more culture and heart than any "living" town I can think of.

But you will definitely need to call for directions: (270) 298-4466.

PITSTOP LIQUORS
HOPKINSVILLE, HOPKINS COUNTY
EVERY OTHER SATURDAY, 4:00–7:00 P.M.

Frank Hudson holds his twice-monthly performances at Pitstop Liquors, a multipurpose roadhouse located right outside Hopkinsville, Kentucky.

Who's Frank Hudson? Why, just a National Thumbpickers Hall of Famer. Just the seventy-four-year-old guitar guru who once rubbed elbows with Merle Travis (1917–1983) and Ike Everly (1908–1975). His playing and singing are still just as solid as they were in his glory years, and you just never know who's going to sit in. In fact, the aforementioned Paducah historian Nathan Blake Lynn and I backed up Mr. Frank for a fantastic night of old-fashioned fun. I went from harmonica to upright bass, while Nathan held his own on the guitar. After the show, he would get a few fingerpicking lessons from the master himself.

The atmosphere at the Pitstop is as laid-back as can be. The whole place is something between a bar, a drive-through package liquor store and a boot scoot. Swinging doors, a jukebox and bar stools (as the old song goes)—you will literally find them all here. Hardwood floors and dim lighting create the perfect backdrop for a fun night of Frank Hudson's songs and storytelling, voiced in the glow of neon beer signs and in the shadow of his trademark cowboy hat.

Come 7:00 p.m., Mr. Frank packs it up and steps aside for the karaoke folks to set up. But he's not done yet. Frank just might sit in and belt out a Hank Williams tune or two over the karaoke mic. It's a rollicking night of local culture that really gets hopping as the evening wears on. Before you

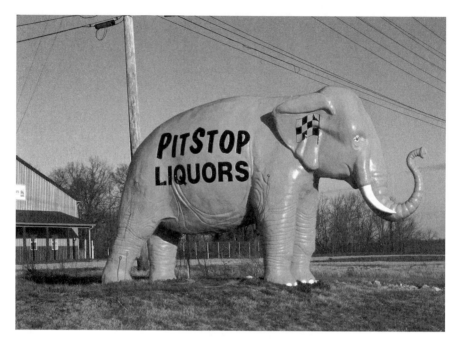

Programmatic "pink elephant" statue at Pitstop Liquors near Pembroke. *Photo by the author.*

know it, the joint is packed to the rafters and the waitresses are up on the bar dancing "Coyote Ugly"–style. For those of you wishing to avoid the ruckus, come early and see Frank Hudson, hear the tunes and appreciate this living legend of western Kentucky.

Punch "6940 Pembroke Road, Hopkinsville, KY" into your GPS. When you get to the roadhouse with the giant pink elephant outside, you'll know either **A:** you shouldn't be driving or **B:** you have indeed arrived.

National Thumbpickers Hall of Fame
Powderly, Muhlenberg County
Late September festivities

In 1998, the National Thumbpickers Hall of Fame (NTPHF) was founded by three individuals who made it their mission to spread the wealth of their knowledge, music and culture—a culture centered on the Muhlenberg

County style of thumbpicked guitar. These three are guitarist Eddie Pennington of Princeton, historian Bobby Anderson of Beechmont and Rodney Kirtley of Greenville.

The purpose of the Hall of Fame is to "honor, preserve and promote the art of thumbpicking, and its heritage." This is accomplished by an NTPHF-hosted, event-packed weekend that commences on Friday evening with a ceremony honoring various living and deceased thumbpickers and supporters. Elements of the guitar style were originated by the black country blues artist Arnold Shultz, who himself was influenced by the "stride" piano players of New Orleans, Louisiana.

Events on Saturday begin with a guitar contest and other thumb-style guitar performances. The festivities conclude with an evening concert spotlighting well-known, contemporary artists. The weekend swells to a crescendo on Sunday with an open-mic jam session in the neighboring Paradise Park.

According to its website, "Anyone can become a member of the NTPHF organization." The supporting members of the NTPHF vote each year on nominated individuals to be inducted into the Hall of Fame. Membership dues are collected annually and are fifteen dollars for an individual or twenty-five dollars for a family membership, which includes school-age children. For more information on becoming a member, please e-mail membership@ntphf.com.

> **"PICKIN' IN THE PARK"**
> POWDERLY, MUHLENBERG COUNTY
> OPEN FOR SPECIAL EVENTS

Powderly is perhaps best known as the hometown of James Best, aka Roscoe P. Coletrain from the original *Dukes of Hazzard* and a guest actor on *The Andy Griffith Show*. The little community is situated between Greenville and Central City and is home to Paradise Park. The park is a re-created small town from the early 1900s, constructed by uprooting old homes and businesses from across the county, transporting them to the park and plopping them down. Among the buildings moved is Merle Travis's childhood home.

Then there's the structure known as the Bobby Anderson Stage. Bobby was the editor for the Muhlenberg County newspaper for years and a strong promoter of thumbpicking and western Kentucky music. He promoted

countless artists over the years, ones whom he believed best represented Muhlenberg County. Every Friday night during the spring, summer and fall, the stage is host to Picking in the Park. The event normally features the amazing Paul Mosely, the Muhlenberg County guitar hero who turned down the lead slot for Bob Dylan multiple times. However, according to fellow guitarist J.T. Oglesby, Paul is so humble that he would never mention that to anyone.

"LET US NOW PRAISE FAMOUS MEN": A DISCUSSION ABOUT WESTERN KENTUCKY THUMBPICKERS

Regarding the Travis style of thumbpicked guitar, I thought I'd let the other experts expound further on the subject. I have enlisted the expertise of Jon Hensley, Lloyd Settle and John T. Oglesby, three passionate supporters of the music. They will help fill in the details.

Hensley is the manager for rockabilly legend Wanda Jackson and outlaw country singer Shooter Jennings (that's right, Waylon's boy). He is also the website designer for Muhlenberg County events. Settle is the promoter for Kentucky's Goose on the Lake Festival. Oglesby is a former National Thumbpicking Champion with numerous national and international rankings.

What makes thumbpicking (guitar) special to you?
Hensley: Thumbpicking is something that I completely associate with western Kentucky and specifically Muhlenberg County. It's an unusual style of playing, and you rarely hear it outside of that general region of the state. The few times that I have been in a town like Nashville and heard somebody truly thumbpick the way Merle Travis and Ike Everly used to… it blew me away. A sense of pride immediately comes over me even though I've never played any instrument in my life. I feel proud of that sound, and I feel like it truly was perfected and established in the county that I was born and raised in.
Settle: I like thumbpicking because of the fullness of the sound. Good thumbpicking sounds like two guitars if you are not looking at the player. Anytime an artist can achieve "oneness with his instrument," good things and creative things are going to happen.
Oglesby: It is purely an indigenous Kentucky style. My first encounter with the style came from my cousin Eddie Pennington. I was mesmerized by the

sound. I could not believe you could play rhythm and lead at the same time. I also loved the old feel to it. I had never seen or heard anybody play like that before since I was into punk and metal at the time. But I [had been] starting to search out old folk, country and any Kentucky-based music, even though I wasn't sure yet what it was. But I knew what sound I wanted to hear; I just didn't know what to call it.

I learned to play old-school country by hanging out at a music barn that used to be in Nortonville called Jim's Opry. It was owned by my wife's grandfather, Jim Clayton. Every Friday, a bunch of old men would gather and play. They helped me learn chords, chord passages, leads and about everything else I needed to know to play guitar. It is also just in my blood. I have four national champions and two international champions in my family.

How did the thumbpicking style originate?
Hensley: I've always heard that Arnie Shultz was the guy who developed that particular style of playing. He was a blues player. The stories that have always been passed down to me were that Arnie passed the technique on to Ken Jones, Ike Everly and Mose Rager. They essentially taught Merle Travis, who popularized thumbpicking back in the 1940s and '50s.
Settle: Obviously, Odell Martin is my favorite, and from what I hear from most of the really good musicians, he was the best. I feel Merle Travis is special for several reasons. One being he grew up near my mother's family and hung out with two of my uncles. I also feel a special bond with Ms. Eula Winders and Frank Hudson.

Ms. Eula was awesome with her playing and her style, which was totally unique, and I feel it contributed to Odell being the best. I think what he did was fuse the style he learned growing up from Ms. Eula with the style he learned from Mose Rager, and the combo was better than anything before or since. Mr. Frank still can play a few of those licks he learned from Odell that were "fusion" licks that no one else plays.

I had a long discussion with John Hartford (1937–2001), who had spent many years researching the topic. He even traced down Shultz's only living relative, a nephew, who had played with him and taped his playing to try to dissect the roots. Hartford told me that he had determined that Shultz traveled to New Orleans each winter and played jazz. [He said] the roots of what Shultz did came from jazz. He mentioned "passing chords." But Shultz was using the thumb to simulate a ragtime piano as a rhythm partner. When in New Orleans, he had a piano as a rhythm, but not in Muhlenberg, so he developed the thumb style to play rhythm with himself. Personally, I

think Merle took it to the streets, and Chet Atkins made it famous because it furthered his career and made him wealthy.

Oglesby: The original credit is given to Mose Rager, but it goes further back than that. Alice DeArmond Jones is the woman that most [folks] credit with starting the style, even though her name is rarely brought up. Her son Kennedy Jones was a good friend with Mose Rager, Ike Everly (the Everly Brothers' dad) and Arnold Shultz (referred to as Shultzy).

Kennedy Jones often said he was just imitating what he heard his mother do growing up. There is one enigmatic figure that I cannot find anything [about]. A man named "Plucker" English. He played a major role, but nobody around Drakesboro [where the style originated] knows anything about him…other than he was a major influence on Mose Rager.

Over time, Mose Rager became known as the father of the style. He had a unique way of playing that set him apart from the others. In his own words, he "choked the box," meaning he put the thump in the bass lines on the guitar. "Box" was a common term for guitar in those days.

Every Friday and Saturday night, they would gather at the railroad crossing at Cleaton, Kentucky, and pick all night. I found out through some older men that the tracks at Cleaton was [*sic*] where the moonshiners would deliver their weekly load. That is something often left out of stories told by most thumbpickers. I learned that and tons of other tales because I live in the area, and I dug around for as many stories as I could find. Arnold Shultz (Shultzy) was another major influence on Mose. He was not a thumbpicker, but he knew a million chords. He was a drifter. There is a story told by many that one time a train pulled up in Cleaton. Shultzy put his guitar down and hopped on. Nobody saw him for a few months. When he returned, he had a bunch of new songs and chords. There is speculation that he was going to New Orleans, which would explain a lot about the ragtime progressions and jazz chords used in the style. Bill Monroe has also cited Shultz as an influence.

Mose Rager took a kid named Merle Travis under his wing. Merle was born in the small town of Rosewood. Merle would also join in at the jam sessions in Cleaton. They all played on the front porch of a store right by the tracks. For the song "Guitar Rag," Mose Rager wrote the guitar part and Travis put words to it. In the [lyrics], he says, "Hanging around singing around the country store." My great-grandfather owned the store they picked at. The building is still there today. Mose Rager has two daughters that are still alive.

Who are your favorite originators of the style?
Hensley: My favorites are Odell Martin, Ike Everly and Merle Travis. Ike may be my favorite out of the three. One of my favorite records is the Atkins-Travis Traveling Show, where Merle and Chet pick and talk the entire record. They mention Mose Rager, Muhlenberg County and Ike Everly.
Oglesby: Mose Rager without a doubt. Mose was not a country music fan, which I have always thought funny. He was a blues and big band fan. He was the touring guitarist for Curly Fox and Texas Ruby. Whenever the bus came near Drakesboro, it would stop and they would all visit Mose's family.

As far as the "next link," Odell Martin is my favorite.

There are no recordings of Arnold Shultz, and I have never been able to find a recording of Kennedy Jones. Last I heard, Kennedy's son Kennedy Jones Jr. is a jazz artist around the Chicago area. He is a good musician and nice guy but does not thumbpick. Nothing at all exists of "Plucker" English.

Where's the best place to hear this music played in Kentucky?
Settle: I think the best place that I know of to hear the good pickin' is the Christmas Eve music event in Hopkinsville, Kentucky. [It's an event that] is held for the homeless people. It has Frank Hudson, the last of the original group that developed the sound; Freddie Russell (who is also in the Thumbpickers Hall of Fame); Eddie Pennington; and Lonzo Pennington. I know of no other place that has that many pickers together other than the Hall of Fame.
Oglesby: Every second Saturday of the month at the Drakesboro City Hall. They have a jam session, and what men that are still alive that knew Mose come and pick along with newer pickers.

Who are your favorite modern players of the style?
Hensley: Eddie Pennington is really fantastic. Obviously, Thom Bresh (Merle Travis's son) is also one of the best.
Oglesby: Eddie Pennington from Princeton, Paul Moseley from Beaver Dam, Royce "Big Daddy" Morgan (he was the original guitarist for Jim Reeves and the Blue Boys) from Beechmont, Larry Stone from Beaver Dam and Steve Rector from Greenville.

If you notice, all of these guys are from Kentucky and are traditional players. They all knew and learned from Mose Rager, as well. There are guys out there that are doing more and being influenced...Tommy Emmanuel and guys like that. These guys are the real deal though. They learned from the father of the style!

Thom Bresh is a great friend of mine and helped me a lot when I was just learning. His father is Merle Travis, and he is an amazing guitarist. Bresh lives in Nashville and grew up in California. His stepfather was Bud Bresh. He owned the ranch where they filmed all the western TV shows in the '50s. *The Lone Ranger*, *The Rifleman* and tons of others were filmed at Bresh's childhood home.

Why do you think western Kentucky was the birthplace of the style? Or was it?

Hensley: I was always told it was the birthplace of the style by friends, family members and other musicians.

Oglesby: Yes, it was. There are tons of different finger style techniques out there, and other areas try to lay claim, but Muhlenberg County is regarded worldwide as the birthplace. The use of the thumb to run the bass lines and the muting (using both the fretting hand and the picking hand) are really what sets the style apart and makes it unique.

The implementation of the ragtime progressions, running bass lines and jazz chords into country is another major factor. Both Merle Travis and Mose Rager are in the Country Music Hall of Fame and the Rockabilly Hall of Fame. I was fortunate enough a few years back to spend the day with Scotty Moore (Elvis's guitarist from the Sun Records days). He told me that all he was doing behind Elvis was attempting to imitate Merle Travis.

Virginia's Piedmont style has the pickers that will argue the hardest about Virginia creating the style, but in the end, Muhlenberg County is regarded worldwide as the home of the style, and Mose Rager is hailed as its father.

The Merle Travis Music Center is located at 750 Cleaton Road, Powderly, Kentucky.

> ### FOUR LEGENDS JAMBOREE
> DRAKESBORO, MUHLENBERG COUNTY
> SECOND SATURDAYS, 6:00–9:00 P.M.

The Four Legends Jamboree is held in Drakesboro, Kentucky, on the second Saturday of each month. Located in the Community Center next to the old Drakesboro Fire Department, the Four Legends Jam is a staple of western Kentucky's musical culture of "thumb lead" or "Travis-style" guitar.

There is no shortage of fancy pickers, good neighbors and great food on hand. The open jam session is always a fun night, with many of the well-known and accomplished local pickers, like Eddie and Alonzo Pennington, likely to attend.

Be sure to check out the Drakesboro Four Legends Fountain while in town too. Constructed in 1992, it commemorates the four leading archetypes of Muhlenberg County's unique guitar style: Kennedy Jones, Ike Everly, Mose Rager and Merle Travis.

The jamboree begins at 6:00 p.m. and ends around 9:00 p.m. at 210 West Mose Rager Boulevard, Drakesboro, Kentucky.

Four Legends fountain in Drakesboro. *Photo by the author.*

LAKELAND JAMBOREE
CADIZ, TRIGG COUNTY
FRIDAY GOSPEL SHOWS, 6:00 P.M.
SATURDAY COUNTRY SHOWS, 10:00 A.M.–4:00 P.M.
(JAM), 6:00–8:00 P.M. (SHOW)

Bringing life to the sleepy, Mayberry-like town of Cadiz is the Lakeland Jamboree, a country music, opry-style show presented every weekend. After all, as the wooden placard hanging in the entryway reads, "Life Without Music Would B ♭."

New owners Ray and Debbie Wyatt continue the tradition set by former host and Cadiz mayor Tommy Wynn, who has passed away. The Lakeland Jamboree sat idle for several years after his death until the Wyatts showed up to patch the leaky roof, clean up the mess and resume the same weekly schedule as before.

Ray emcees and sings with his trademark baritone voice while renowned instrumentalist Charlie Stamper handles fiddle duties. Stamper is the eldest son of legendary Knott County fiddler Hiram Stamper and the older brother of Hiram Jr. and Art Stamper, an architect of the bluegrass sound. He is also

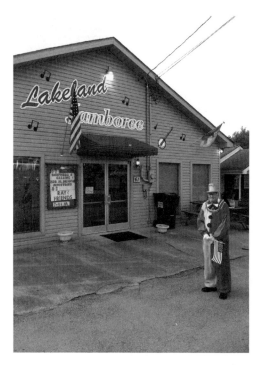

Bennie Allen clowning around outside the Lakeland Jamboree, Cadiz. *Photo by the author.*

a distant cousin of Pete Stamper, the famous comedian and emcee of Renfro Valley. Born in a log cabin on the Cumberland Plateau in 1930, Charlie started off playing a "thrum-bow" (or mouth-bow) whittled from a branch by his father. He later moved on to a homemade banjo that he and his father carved from the stump of a black gum tree. Eventually, he graduated to the fiddle, at which he excelled so much that he was once asked to back up Loretta Lynn. Stamper's pedigree alone is worth the door charge at the jamboree.

Like the *Grand Ole Opry*, there's a certain comfort level among all the Lakeland participants, with folks coming and going, on and off the stage during the performances. It's a sort of hillbilly musical chairs, if you will. And Ray Wyatt isn't above stopping the show to pull out his joke book and rattle off a few one-liners. I felt right at home, even when he invited me up to pick a few with the band.

Country music is important to the Wyatts, Stamper and their Trigg County audience. It's also important to the jamboree's eighty-two-year-old next-door neighbor, Bennie Allen, who loves the jamboree so much that he flags down passing cars while dressed like a clown. That's right, dressed literally as a clown. It is his hope that he will attract customers to a new love of traditional country music.

"My father played fiddle and my mother played banjo," Allen explained. He grew up following his parents to various "pie suppers" and Depression-era square dances.

"We used to play in an old log barn too," Allen said. Allen also claimed to be a running buddy of saxophone superstar (and my distant kin) Boots Randolph (1927–2007), who he picked music with when they weren't out "picking peanuts on the farm." It was bizarre, but I could have sat and listened to this old clown talk all night about "the good ol' days."

While in Cadiz, be sure to visit the famous antique shops or take a bald eagle tour around the Lakes area. The Land Between the Lakes is a habitat for our symbolic national bird. In fact, one might just fly over your head while you're downtown. Purchase one of Trigg County's famous cured hams too. Cadiz has its Ham Festival every October.

Lakeland Jamboree's live bluegrass, gospel and country music shows start at 6:00 p.m. Refreshments are available in the foyer. For the Saturday performance, admission is three dollars for children under twelve, five dollars for guests over twelve and seven dollars for reserved seats. Guests can expect entertainment to last from 7:00 to 9:30 p.m. Call (270) 839-1432 for more information. The Lakeland Jamboree is located at 61 Jefferson Street, Cadiz, Kentucky.

OTHER EVENTS

Jam Night at the **Bluegrass Museum** is on Thursday nights at 117 Daviess Street, Owensboro, Kentucky. One-dollar admission.

Community Dance at Ohio County Park is on Saturday nights except the last two weeks in December, 7:00–10:30 p.m.

Country Music Warehouse, Livermore, Kentucky.

The **Green Dragon** Saturday night jam is in Madisonville, Kentucky.

Home of the Legends Jam is on second Saturdays at the Drakesboro Fire Station, Drakesboro, Kentucky (across from the Mose Rager estate).

McQuady Bluegrass Jam, brought to you by the Breckinridge Bluegrass Association, happens every fourth Saturday at 6:00 p.m. at the McQuady Fire Station.

Thumbs Up Music store jam is on Saturday mornings at 105 Midtown Plaza, Beaver Dam, Kentucky. (270) 274-0631

Traders Mall Flea Market features gospel singing, talent shows and picking in Reidland, Kentucky. Exit 16 off I-24.

CENTRAL KENTUCKY

Bluegrass Mythos

Is there anything more beautiful than a sunset in the hills of central Kentucky? Whenever I've been lucky enough to experience such a sight, my mind goes wild, snapping off rolls and rolls of mental film. I appreciate the rolling, azure waves of grass and the rickety miles of split-rail fences. Horses trotting, foxes darting and roosters crowing. Nature whistles melody through the sycamores and pines, hoping her influence will strike the right ear. The lazy Green River, Pope Lick Creek and the Cumberland lollygag along, warbling low like a grandma humming a tune. We are blessed to live in this un-Commonwealth. "Too blessed to be depressed," as they say.

However, there are still reports here of more ghostly things. Like otherworldly bells. Perhaps they are chiming from the neck of a rogue black bird, the "Belled Buzzard," as Irvin S. Cobb called it. It's a sort of feathered harbinger of doom from the Bluegrass State. Even the *New York Times* reported on these "invisible sounds of mournful mingled music" thought by locals to be "war sounds from Heaven." The writer describes how the mystery was solved when "a buzzard sailed…by with a…bell swinging from its neck, jingling forth in touching tones."

The gurgling sounds of headless dogs running up and down the banks of the Green River have long been reported here too. "The Goatman" of Pope Lick Creek is another star of central Kentucky's culture. Storytelling is

a form of communal "music" all its own, and I believe it is just as important to keep alive the old legends as it is the old music.

But let us now turn our attention to the Big Three of central Kentucky: Berea, Frankfort and Lexington. While I have yet to play music in Berea, I picked a little at the Black Barn jam in Conway (located midway between Berea and Renfro Valley). The Black Barn has hosted an authentic barn dance for several decades, so be sure to work in a visit when you're in the area. Down the road, Renfro Valley itself is so rife with history that my entry below seems insufficient. Special thanks to Joe Fothergill for helping me compile a brief history of *the* most famous barn dance in all of Kentucky.

Then there's Frankfort. I must admit I don't get to our state capital that often, and I don't follow its politics. However, I *have* attended a dance demonstration by the Capital City Country Dancers. Who are they? Well, it is one of the most intriguing things you'll ever witness. The jaunty sound of sixteenth-century reels performed live on esoteric instruments and echoing throughout a 1950s-era gymnasium is eerily awesome. See details below.

Frankfort's bluegrass jam at the First Christian Church recently fell quiet, as leader James Webb currently concentrates on teaching music. But Tony's BBQ Barn in nearby Lawrenceburg is picking up the slack, conducting a bluegrass jam every Monday night. There is also the Country Place Jamboree that has been around since the 1970s. It's a little hard to find if you're just trying to wing it, so pack your global positioning device and head for 60 Old Sheep Pen Road, Frankfort, Kentucky. (But remember to always phone ahead!)

David Wagoner in Carlisle, Kentucky, hosted a jamboree at an old general store in Nicholas County for three years. Wagoner's jam was unique in that it included an educational component for kids. The Nicholas County Historical Society owns the building now and has redesigned the main floor to be a museum, a genealogical library and an events space. It is currently remodeling the upstairs to be a performance hall.

Wagoner says hosting the general store jam for those three years was a great experience, but he has recently happened upon a much more rewarding opportunity: hosting the "invitational jam" at the Windy Corner Market Restaurant. For the past two years, David has been rounding up his friends to jam at the restaurant each Friday night. They play from 6:00 to 8:30 p.m. (closing), get fed and take home a little cash in their pockets. He plays old-time and bluegrass but started out as a contra dancer. Wagoner was inspired to play music after attending contra dances in Lexington, where, says Wagoner, "the only thing that looked more fun than dancing was being up there playing music."

The Athens of the West

Speaking of Lexington...

Dubbed the "Athens of the West" by the nineteenth-century travelers who were struck by its aristocracy, Lexington still boasts a reputation of culture and class. Quintessential blue-blooded fusspot Mary Todd Lincoln was born and raised in Lexington, as well as many famous others. In fact, some of America's most important people have spent a good portion of their lives in the capital of the Bluegrass State, including U.S. president Abraham Lincoln, Confederate president Jefferson Davis, Confederate general John Hunt Morgan and U.S. senator and secretary of state Henry Clay. Modern residents have included Vince Gill, George Clooney, Naomi Judd and my favorite: Jim "Ernest P. Worrell" Varney (RIP).

Throughout the 1990s to today, I have shared bills with such great Lexington groups as Crown Electric, Sturgill Simpson's Sunday Valley and Fifth on the Floor, bands that occupy the local "alternative country" scene. Venues like Lynaugh's Blues Emporium and the Dame hosted these and other amazing shows, only to be shut down later or even demolished by the city (as was the case for the Dame). Lynaugh's recently reopened and hosts jams on occasion. Next door, Cosmic Charlie's serves as the larger-size room, presenting a variety of mid-level acts from the Tillers to Jessco White, the Dancing Outlaw. Across town are two theaters that serve as the homes for the "taped live" radio shows *Woodsongs Old-Time Radio Hour* and *Red Barn Radio*. They are the Lyric Theatre and ArtsPlace, respectively. These are staples of Lexington's local roots scene and prerequisites for any reader interested in the topic of opry-inspired radio shows.

Renfro Valley
Rockcastle County

Lexington's *Woodsongs* and *Red Barn Radio* are both based on a formula that is epitomized by the *Renfro Valley Barn Dance* broadcast, which debuted on WLW on October 9, 1937. The broadcast eventually went quiet, but Renfro Valley—the real village and its stage show—endures into a new century, presenting classic country and gospel music to tourists each week in Rockcastle County, Kentucky. A nearby radio station still broadcasts the long-running Sunday *Gatherin'* program. Given its many contributions as

"Kentucky's Country Music Capital," let it be said that Renfro Valley is the quintessential entry of this entire book.

The Valley boasts a fifty-five-acre complex in south central Kentucky, a mere stone's throw from Interstate 75 off Exit 62. With a litany of shows on the bill, you'll need to consult the website to pick through the selections. Gospel shows are performed in the Red Barn or the Brush Arbor cabin. The barn dance starts at 7:00 p.m. every Saturday night on the main stage, followed by the jamboree at 9:00. The Kentucky Music Hall of Fame is just next door, too. Don't miss it either!

Founded by the famously enterprising John Lair, the Renfro Valley barn show has always boasted great classic country, southern gospel and mountain music. Lair got the idea from his years at WLS-AM's *National Barn Dance*, a precursor to the *Grand Ole Opry*. Lair's *Renfro Valley* spinoff was performed at Cincinnati, Ohio's WLW studio but later moved to the Memorial Hall in Dayton, Ohio.

However, Mr. Lair was no dummy. He had enough smarts to relocate the show to a place closer to home, one that just so happened to be along Route 25, a major American north–south corridor. Mount Vernon, Kentucky, is where the show would settle, broadcasting its down-home proceedings on CBS affiliate WHAS-AM in Louisville. Again, the show is no longer carried over the airwaves, but once you step within those famous halls, you can almost hear the ghostly echoes of shows past ringing from the rafters, from the great Red Foley to the Coon Creek Girls to country comedian Old Joe Clark.

Renfro Valley was born from the nostalgic childhood memories Lair recalled later as an adult. Back in those days of yore, Saturday nights saw folks gather in barns, where manure and other unsightly material would be swept aside so a hoedown could be had. Salt, wheat chaff or grain was thrown on the floorboards for traction, and the local musicians would play all night.

A similar farm motif was popular on many of the old radio shows of yore. And there were dozens of them! The *National Barn Dance* began on April 19, 1924, and by November 1925, it was being broadcast from the WLS-AM ("World's Largest Store") studio in the Sherman Hotel—a far cry from a smelly old barn. *The Midwestern Hayride* on Cincinnati's WLW-AM ran from 1947 to 1972 and featured a rustic "realism" as well. The *Old Dominion Barn Dance* on WRVA out of Richmond, Virginia, also was a studio production, performed in front of a very large live audience. WWVA's old *Wheeling Jamboree* studio broadcast endures to this day.

By this point, you've probably asked the question "why?" What gave rise to such nationwide popularity of barn dances? Quite simply, it was one thing

and one thing alone: the Depression. As the economy slowly recovered, corporations descended on Appalachia looking for desperate, unemployed workers. Industry bigwigs knew that "farm life" produced a work-or-starve discipline within the people. To the coal magnate or railroad tycoon, a farmhand was a dependable worker who could be trained. (This became even more prominent during the war years.) Those newly hired folks who moved north for employment grew to miss their families and those old-timey ways of life. Radio filled that void, and advertisers filled the pockets of the radio industry. It was copacetic.

Live music, local color, excellent shows or all the above—people wanted entertainment like the kind coming from that crackly, battery-powered radio speaker. Even the booming record industry was overshadowed by radio in the late '20s to early '30s. According to Charles K. Wolfe's book *Kentucky Country*:

> *The Depression ruined the phonograph industry. In 1931, 10 million were sold, as opposed to 34 million in 1928. In 1930, there were 14 million radios in the country and 600 stations. By 1935 there were 5,000 programs that featured "hillbilly" music, generating $25 million in revenues. Musicians struggled along* [making] *$15 or $30 a week.*

All over the country, folks just couldn't get enough of that Saturday night down-home sound—entertainment provided by the likes of:

Homer and Jethro, perhaps the biggest stars to come from Renfro Valley. They began their act in 1941 and continued on to Nashville, where they turned their parodies of popular songs into radio hits. Patti Paige recorded "How Much Is That Doggie in the Window?" Homer and Jethro recorded "How Much Is That Hound Dog in the Winder?" Despite the shtick, they were both amazing musicians.

Jerry Byrd reached national success as a lap steel guitar player. He was in high demand after leaving Renfro for studio work and touring with Ernest Tubb and Red Foley. Byrd was born in Lima, Ohio, and first debuted on *Renfro Valley* when the show was held in Dayton, Ohio. Byrd's mission in life was to bring Hawaiian music back to Hawaii, and he eventually did just that. But that's another story.

Ernest Cornelison (aka Ernie Lee) was never a national star, but he did substitute for Red Foley on his *Prince Albert Show* in 1948. Ernie was at *Renfro* from the beginning to 1944. He spent the balance of his career at WTTV-TV in Tampa, Florida.

Renfro Valley sheet music © 1935. *M.M. Cole Music Publishing Co., Chicago.*

The Coon Creek Girls might have garnered the most worldwide attention, having been requested by the Roosevelt administration to sing for the King and Queen of England. Lily May Ledford Pennington became a solo performer later in life and was very important during the folk "scare" of the 1960s.

Jimmie Skinner (1909–1979) is perhaps my personal favorite. Like so many other country and folk singers, Skinner was influenced by Jimmie Rodgers, the "Singing Brakeman." Skinner's powerful baritone voice and songwriting skills won him popularity and a contract with Capitol records. His rendition of the classic "Dark Hollow" is a must-have in my book. Jimmie's original tune "Let's Say Goodbye Like We Said Hello" was recorded by Ernest Tubb, and his "Doin' My Time" was made famous by Johnny Cash.

Then there's Red Foley, the show's part owner and one of the first Kentuckians inducted into the Country Music Hall of Fame. He was most famous for his tune "Peace in the Valley" and for emceeing the *Ozark Jubilee* on television. He was also the host of *The Prince Albert Show* from 1946 to 1952 and a member of the *Grand Ole Opry*. Foley also emceed both *Avalon Time* and *Plantation Party*, two shows that aired first over WLW but relocated to Chicago's WLS.

Foley also helped host the Berea Homecoming Festival, an event put on by Lion's Club district governor Dr. David Settles. Many stars from the *Grand Ole Opry* and *Renfro Valley*, plus Settles's own band, the Renfro Ramblers, performed onstage at the rugged outdoor Indian Fort Theatre. The event was meant to celebrate the achievements of all Berea-born entertainers and Renfro Valley stars like Foley, Lair and the Coon Creek Girls. The annual three-day event lasted fifteen years, from 1951 to 1966.

Okay, back to contemporary times.

Renfro Valley really does have it all. For the shopper in you, the Renfro village offers unique handmade crafts—the kind that can be found only in the foothills of Appalachia. Come dinnertime, the Historic Lodge Restaurant and the Back Porch Smokehouse serve up Renfro Valley's famous fried chicken, pulled pork barbecue and a feast of other homemade southern specialties. Camping enthusiasts are invited to stay at the award-winning Renfro Valley RV Park, which has been awarded the "Four W" rating from the Woodall's Club. The park offers all the amenities and security found at most hotels.

As you can tell, Renfro Valley is music, history, shopping and so much more! Visit online at www.renfrovalley.com.

RENFRO VALLEY GATHERIN'
PRE-RECORDED BROADCAST
WRVK 1460, ROCKCASTLE COUNTY

In 1957, when WHAS and the CBS network decided to discontinue their broadcast of the *Renfro Valley Barn Dance* and its Sunday morning sister act, the *Renfro Valley Gatherin'*, the shows' originator, John Lair, decided to save the day and start his own station closer to home. Thus, WRVK, "Your Homefolks Station," was born. Instead of originating from Louisville, programming began broadcasting from the old Renfro Valley Pioneer Museum Building, a humble facility that had sat unused for years. A new 500-watt radio transmitter was secured, and the shows went live.

The *Barn Dance* was not revived, but the *Gatherin'* continued on to become the third-oldest continually broadcast radio program in America and the second-longest such program featuring country music and/or rural-oriented programming. Only the *Grand Ole Opry* (1925) and *Music and the Spoken Word* (1929) have been continually broadcast longer.

John Lair began the show as the *Renfro Valley Sunday Morning Gathering* around 1940–41. His original concept was to recreate the feel of old pioneer "getherin's" [*sic*] that were held in Renfro Valley. At the time of the show's inception, World War II had just started, and times were tough. The farm population was being deported, depleted and converted into world-weary soldiers. The devastating effects of war wreaked havoc on the souls of these poor country boys who were forced to slaughter other human beings like farm animals. Indeed, things were bleak for my grandparents' generation, but while Walter Winchell and Edward R. Murrow were dispensing doom about the war, John Lair's calming demeanor hit the air. Over the CBS network, Lair informed folks about how the spring flowers were starting to bloom and planting season was rapidly approaching.

According to Renfro Valley historian and *Kentucky Explorer* contributor Joe Fothergill, the *Gatherin'* was like "the Hillbilly answer to Franklin Roosevelt's popular *Fireside Chats*, but with music." Says Fothergill, "Listening to John's delivery was as soothing and reassuring as any politician's promise that better things were coming. World problems were not an issue."

This might sound hokey to the jaded youth of today's fast-food culture, but Lair was a voice of reason that penetrated the gloom during this time of death and despair. (Aside: I find it ironic how the same generation that

was once regarded as "Archie Bunker" bigots and "Ward Cleaver" fuddy-duddies has since been repackaged as the "Greatest Generation." Personally, I believe they are indeed the latter, but the media should not be allowed to have it both ways.)

Lair devised the *Gatherin'* to be a nostalgic escape by featuring songs of home and faith. It was not meant to be overtly religious but showcased plenty of gospel music and sentimental group singing. The program was also presented as a live stage performance up until 2007. The current incarnation of the program is recorded entirely in a studio onto a disc and shipped to affiliates as part of a syndication deal. Pam Perry Combs sings much of the music, which includes country and gospel favorites. Combs was a member of the New Coon Creek Girls during the 1980s and '90s. She also helped form the all-female group Wild Rose, which recorded for Capitol records.

Over the years, WRVK has shifted with the whims of each new manager, but the *Gatherin'* always held its spot. The station had been converted to a gospel broadcaster in the 1980s, but WRVK returned to a country music format in 2002. Although it is no longer a part of the Renfro Valley Entertainment Center, WRVK does continue to be the flagship of the area's rural culture. New owners Charles and Bobbie Saylor have restored the station to a classic country format that serves Rockcastle County and is "very much in keeping with the station's early traditions." Yes, WRVK is once again "Your Homefolks Station!"

WRVK, home of *The Gatherin'* radio program. *Photo by the author.*

WRVK's broadcasting studio and transmitter are located on Red Foley Road, off U.S. 25 north of Mount Vernon near KOA Campground at Renfro Valley. WRVK's business office is located at 35 Lovell Lane inside Saylor's Furniture in Mount Vernon. WRVK is a 1200-watt broadcasting station, a substantial upgrade from its original 500 watts. The *Gatherin'* is also streamed over the Internet at www.wrvk1460.com.

BEREA AREA BARN DANCE
BEREA, MADISON COUNTY
WOODS-PENNIMAN COMMONS
8:00–10:00 P.M. (CHECK LOCAL LISTINGS)

Up the road from Renfro Valley is one of my favorite towns: Berea, Kentucky, where Berea College hosts its Barn Dance and Cakewalk.

A cakewalk, in case you didn't know, is a folk dance that originated in the antebellum South. Slaves developed the style by mimicking the fancy Victorian dance steps of their masters. Over the years, it combined with the chalk dance, where participants follow a square or circular chalk line around the room, improvising dance steps along the way. To win the coveted prize of, well, *cake*, the dancer must either impress the judge with his or her moves or land on a winning number, letter, color or shape when the music stops. (Years ago, I attended a couple of cakewalks in middle Tennessee: one in Fairview and one in Pleasantview. Both events conducted the dance differently, but both had an overall church potluck feel, similar to the southern tradition of a pie or "box" supper.)

The event is held either on the streets of Berea during warm weather, at the Acton Center or inside the Woods-Penniman Commons building. Woods-Penniman Commons is the campus post office, originally constructed in 1930 to be a women's gymnasium. The Acton Center is the log structure that hosts a variety of occasions related to folk studies.

All proceeds go to the Central Appalachian Prisoner Support Network, a group working with prisoners and their families in central Appalachia. The group strives to maintain human rights, promote rehabilitation and help keep families together.

Admission is two dollars for students and five dollars for others; children under ten are free, and the maximum is ten dollars per family. Cakewalk tickets are sold separately at two dollars. If you've never attended a

cakewalk, you owe it to yourself to go. Come on...dancing *and* cake? What's not to love?

Chestnut Street and Scaffold Cane Road, Berea, Kentucky, 40404.

BEREA'S PICKIN' ON THE PORCH
BEREA, MADISON COUNTY
THURSDAYS AT THE DEPOT/CABIN PORCH, JUNE–AUGUST
THURSDAYS AT THE FIRST CHRISTIAN CHURCH, SEPTEMBER–MAY

Donna Lamb and her father, Lewis Lamb, have been running an old-time jam at the Berea Welcome Center for eight, soon to be nine, years. The center is located in the old L&N train depot where folks once bought their tickets. Planning for the porch jam began after tourism board member Belle Jackson approached the Lambs about starting up an area attraction that re-created Berea's "old-time socials."

The jam mixes old-time music, folk and bluegrass—really any kind of music, so long as it's acoustic. "We allow one electric bass," Donna said, "but it's turned down low."

The depot is mostly original, though slightly renovated, and the events that happen inside are like a scene from the past, especially when a noisy freight train rumbles by. This jamboree hearkens back to when Lewis Lamb was playing fiddle in the early 1960s. Back then, dances were coordinated by Berea patron Ethel Capps, who held them on the tennis courts but used recorded music. Lamb stepped up and talked to Capps about adding live music. After handing her his phone number, a new dance format was soon in the works. To this day, Lewis Lamb is credited as the one who brought *live* music to Berea College.

At first it was just fiddle and guitar, but it wasn't long before Capps wanted to add piano and a bass. Professors and their wives started showing up, and the dance became a hit. Musicians got to studying different styles of music, and soon they were incorporating waltzes and Scottish tunes into the mix. Danish and English traditions were absorbed into the repertoire as well. "One thing just naturally led to another," Donna said.

Mind you, before dances were socially acceptable, "play party games" were the norm. Folks would gather just to play games and socialize, since it wasn't always common (or moral) to add music. That all came later.

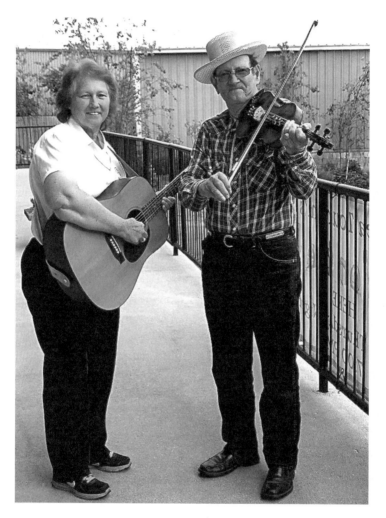

Pickin' on the Porch with the Lambs, Berea. *Photo by the author.*

Nowadays, the old tradition of an Appalachian dance thrives in Berea thanks to the Lambs. Lewis is currently seventy-three years old, but he still saws away on the fiddle like he did in the '60s. Square and contra dances are held once or twice a month in the Acton Folk Center, and a cakewalk/dance is held in the Woods-Penniman building on campus.

"There's no drinking and no bad talking," Donna added. "We have all ages show up to play, from eight and up."

More info on Berea activities can be gleaned from the website www. berea.gov.

WOODSONGS OLD-TIME RADIO HOUR
LYRIC THEATRE
LEXINGTON, FAYETTE COUNTY
MONDAYS, 6:45 P.M. SEATING

Woodsongs is not your typical concert. Host/folksinger/self-described "tree hugger" Michael Jonathon characterizes it more as a "musical conversation." It is also a live-audience broadcast where "your laughter, applause and enthusiasm" is broadcast along with the best mainstream (and not-so-mainstream) acts of the world. *Woodsongs* can be heard on over five hundred radio stations and the American Forces Radio Network in 173 countries. It's a television show too, reaching into millions of TV households across North America on Public Television, and is seen by millions more on the Internet.

The show is a fantastic experience for musicians so lucky to join the *Woodsongs* ranks. From Jakob Dylan to Bobby Rush, the late Richie Havens to Leroy Troy and his Tennessee Mafia String Band, the list goes on and on. Yes, it's a veritable who's who of earnest and endearing roots-based music of every genre. What's more, the staff is accommodating and the place is always packed. Having recently relocated from the Kentucky Theatre, the show has a new home at the Lyric, another old theater on Third Street.

Woodsongs is always a wholesome family show with heartfelt performances encouraged all the way. Michael also likes to "keep it real," allowing the little human glitches to stay in the show instead of editing them out of the final product. And don't I know it! When I performed on the show, I accidentally knocked the bridge of my banjo, sending the whole thing violently out of tune for the entire song. But hey, that stuff happens in live music. Besides, this is Kentucky, not Nash-Vegas!

Mr. Jonathon's stage banter often includes moral lessons about folk traditions or the stewardship of nature. He also encourages parents to support the arts and music education for young people. In fact, Jonathon is happy to invite children up on stage to run around and dance to the show's final number. So if you attend, bring the kiddos!

Visitors to the Lexington area are cordially invited to attend the next…say it with me: *Woodsongs Old-Time Radio Hour*!

There is plenty of free parking in the lots alongside the Lyric Theatre. Downtown Lexington, 300 East Third Street, Lexington, Kentucky, 40508.

RED BARN RADIO
PERFORMANCE HALL AT ARTSPLACE
LEXINGTON, FAYETTE COUNTY
WEDNESDAYS, 7:00 P.M.

With a barn-themed backdrop akin to its famous Nashville cousin, *Red Barn Radio* just might remind you of the glory days of the *Grand Ole Opry*—long before the latter event turned into a showcase for twangy pop music posers. But I digress.

Red Barn Radio showcases any old-time, bluegrass and traditional country musicians of note, just like the *Opry* used to do. Again, I digress. The acts that grace the *Red Barn* hail from not just our Commonwealth but anywhere in the world where Kentucky music has spread to and flourished.

Taking note from its other Lexington-based cousin, *Woodsongs Old-Time Radio Hour*, *Red Barn Radio* engages in as much conversation with its talented guests as it does music. When my band the Dirt Daubers played there, we had only been together a few weeks, and we definitely "weren't ready for prime time." Luckily, the deejay loved to chat, so most of our on-air time was spent shooting the breeze and running out the clock. The few songs we did attempt were "close enough for government work," as they say.

The stated purpose of *Red Barn Radio* is to "enliven and archive Kentucky's musical heritage, and bring to the airwaves a uniquely refreshing and folksy hour of Americana programming."

Red Barn Radio is a syndicated weekly broadcast on the radio with its live tapings recorded in front of an audience. This allows music lovers a chance to experience grass-roots artists up close and personal. This is its broadcast schedule:

Lexington: wuky.org, Saturdays at 8:00 p.m.
Statewide: weku.fm, Saturday evenings at 9:00 p.m. on WEKU 88.9 Richmond, 106.7 Frankfort, 90.9 Hazard, 88.5 Corbin, 96.9 Barbourville, 102.5 Middlesboro and 95.1 Pikeville; repeats at 3:00 a.m. on Sundays.
East Tennessee: wets.com, Fridays at 11:00 a.m., Sundays at 8:00 p.m.
Lost Creek, West Virginia: wotrfm.com, whawradio.com.
Regina, Saskatchewan: cjtr.ca, Wednesdays at 5:00 a.m. CST.

> ### TRADITIONAL DANCE ASSOCIATION/
> ### "MOSTLY WALTZ" AT ARTSPLACE
> #### SATURDAYS/FIRST FRIDAYS

Also occurring at the ArtsPlace building are the Lexington Traditional Dance Association's weekly contra dances, 8:00 to 11:00 p.m. on Saturdays (7:30 p.m. for new dancer workshops).

For waltzers and other ballroom-style dancers, the Lexington Vintage Dance Society hosts a social dance on the first Friday of each month, open to the public, with live music. These events include lots of waltzes, occasional polkas, schottisches, tangos, one-steps, foxtrots, blues or other favorite dances. There is instruction from 7:00 to 7:45 p.m. on a selected dance topic. Dancing follows directly, going from 8:00 to 10:00 p.m. The cost is seven dollars per person or four dollars for full-time students. "Mostly Waltz" is in the Performance Hall at ArtsPlace.

From I-75/I-64, take Exit 113 toward Lexington; turn left on Third and right on Mill. ArtsPlace, 161 North Mill Street, Lexington, Kentucky. Call Danby at (859) 420-6780.

> ### LINCOLN JAMBOREE
> #### HODGENVILLE, LARUE COUNTY
> ##### WEEKLY SHOWS

Joel Ray Sprowls, the brains behind Hodgenville's Lincoln Jamboree, was born and reared around Buffalo, Kentucky. As a youngster, he emceed several area talent shows and festivals and later became motivated to start his own show in 1954. He opened the Lincoln Jamboree with the goal of providing family entertainment and excellent live country music to the good folks of LaRue County.

In 1959, Sprowls opened Joel Ray's Restaurant on a swatch of prime real estate right next to Abraham Lincoln's Birthplace. Not a bad place to do business, considering that next door is one of the most sacred spots of American history. (This highly visited National Park features Lincoln's old log cabin birthplace, or at least a very convincing mock-up.)

Two years later, Sprowls erected a brand-new jamboree building near the restaurant. Unfortunately, that building was destroyed in a 1968 inferno, but

Joel Ray soldiered on with his dream, replacing the old facility with the one his fans enjoy today. Now into his sixth decade as the jamboree's owner and producer, Joel Ray continues the family show tradition each Saturday night with special guests and the Lincoln Jamboree Gang house band.

The Jamboree Gang, along with occasional guest singers, perform music "the way fans like to hear it." As their website states, "From country classics to today's top 40, from foot-stomping rock 'n' roll to favorite hymns, the performers add a personal and professional touch." Sprowls's success even landed him a mention in a 2005 issue of *Forbes Magazine*, which described him as "an immortal talent."

While dining at Joel Ray's Restaurant, customers can also view a display of the actual costumes, instruments, photos, autographs and other relics belonging to Elvis Presley, Ernest Tubb and many other icons of country music. On a similar note, the souvenir store at the Abraham Lincoln Birthplace National Park must be seen to be believed. Picture it: thousands upon thousands of trinkets, whatnots and doodads laid out in a giant room, each adorned with the bearded mug of our homeliest president. It can be unnerving, but it is definitely worth a visit.

Honest.

BURGIN BARN
MERCER COUNTY
FRIDAYS, FREE FOOD, 6:00 P.M., SHOW AT 7:00 P.M.

I hate arriving late to an event, but after I finally found a parking spot way back in the mud, drizzle and drear, I was somehow able to get a better perspective of the Burgin Barn. As I slowly trudged up to the door, I sensed a dull pulse of music through the wooden walls and the vague foreshadowing of timeless things to come. The barn is a classic jamboree structure with the usual Christmas lights, American flags and western lettering. Stepping inside, I had to squint my eyes to adjust to the dim, glowing gaslights. A friendly lady at the door took my money and asked if I was that harmonica player from Paducah who had called earlier. I guess I must stick out like a sore thumb because she had me pegged. I gave her my name and took my place on a church pew in the back row. The opry-style barn show was in full swing—and for its sixteenth year, come to find out. There were probably about seventy-five folks in attendance.

As always, I made sure to take in all the sights first. Foam-core advertisements for area sponsors formed a header above the stage. Elsewhere were bits of horse tack, barbed wire, straw hats, feed sacks, gourds and antique toys. Old iron skillets dangled in rows from the exposed rafters of a tall arched ceiling. University of Kentucky basketball posters hung crooked next to autographed "head shots" of country stars. Later, I noticed emcee Tommy Hurst had a few pictures taken of himself with the late great Hank Thompson. Turns out they were big buddies back in the day.

Mr. Hurst usually plays bass with the house band, the Kentucky Strangers, but tonight he would be in charge of "quality control." Hurst sauntered back and forth, constantly circumnavigating the audience to monitor the overall mix. Then, standing directly in front of center stage in full view, he would gesture back to the soundboard to either "turn her up!" or "turn him down!" As directed, his wife would oblige, tweaking the faders but fussing at him over her own talkback mic. Their dynamic was entertaining to watch.

My favorite highlights of the show were Winston May's pedal steel and Mike Mackin's piano licks. (Mackin also performs at the 68 Jamboree in Lebanon, Kentucky.) As is often the case in our talented state, the band was better than any Nashville, Tennessee or Branson, Missouri act. There's just something in the water here, I guess.

However, for me, the best part was ten-year-old Alex Miller, aka "Li'l Hank," who stole the show. Even with his gigantic, blindingly white cowboy hat, Alex probably stands a hair over four and a half feet tall. But he packs a mean wallop when it comes to belting out those Hank Williams tunes. It was also fun seeing him warm up before the show, practicing his "aww, shucks" charisma before assuming the stage. His banter over the mic was as laid-back and dry as your most seasoned old pro. Yes, seeing "Li'l Hank" alone was worth the price of admission.

I took the stage during the second set and got a halfway-decent response from the crowd. Natalie Berry followed up with her spot-on yet broad impersonation of Patsy Cline. A good time was had by all, but as soon as the clock struck ten, folks were up out of their pews, into their cars and off to bed. I looked up and they were all just *gone*. I have a feeling that, to many of the folks in Burgin, the barn is just as essential to their weekly routine as going to church. It was an enjoyable, wholesome evening, and I suggest everyone check it out, especially if you're going to be in the Harrodsburg area.

But hurry before "Li'l Hank" grows up and isn't as "Li'l" anymore.

The address is 345 Buster Pike, Burgin, Kentucky. Phone ahead at (859) 265-1415 or (859) 748-9689.

CAPITAL CITY COUNTRY DANCERS
THORNHILL EDUCATION CENTER
FRANKFORT, FRANKLIN COUNTY
FRIDAYS, 7:00–9:00 P.M.

Most Friday nights, historic dances of the 1600s through early twentieth century are demonstrated by the Capital City Country Dancers. Meanwhile, a veritable orchestra of dulcimers, fiddles and mandolins picks from the gymnasium stage. Dance steps include the English court, country and barn dances, waltzes, early American square dances and more.

You name it, leader Don Coffey teaches it: from the American colonial, Revolutionary and Civil War eras to the early 1900s. The bowler hat–bedecked Coffey is an expert on all things colonial. In fact, a conversation with him reminds me of the great John Jacob Niles, another anachronistic conduit of arcane history. His band of some fifteen-odd folks sets up on the stage of a 1950s-era high school gymnasium. The acoustics of this huge old room imbue the music with glorious reverb.

Every kind of plinking, plunking instrument, from dulcimers to plectrum banjos, violins to mandolins, cimbaloms to pianos, pulses out the lively tones of archaic reels, jigs and foxtrots. The caller stands beneath the basketball net and sings out to the dancers who fill the floor to center court. Coffey mans the hammered dulcimer and never misses a lick. To my ear, his instrument sounds like ball bearings bouncing off the pins of a Plinko game. The whole thing is an infectious, ear-tingling experience.

All ages join in the fray, both onstage playing music and offstage on the dance floor. Halfway through the night, and after the snack break, dancers grab a seat in the bleachers and reverently listen as Coffey lays out the group's plans for the following months. Future shows and dance demonstrations are discussed, but bits of American history seem to always find their way into Coffey's dissertations.

Indeed, Don Coffey's expertise runs deep through our nation's history and its many jaunty steps: quadrilles, colonial contra dances, Appalachian big sets, running sets and other styles of dancing I couldn't do if my life depended on it. They even attempt some more modern dances too. (Excluding the moonwalk, I assume.)

Couples are welcome to join, as are singles, teens and children with parents or guardians. Snacks are served at "halftime." Join the fun and learn some history while you're at it.

700 Leslie Avenue, Frankfort, Kentucky.

AKEMON'S BARBERSHOP JAM
PARIS, BOURBON COUNTY
TUESDAYS, 3:00–6:00 P.M. (OR SO)

Akemon's Barbershop Jam is admittedly a small-time jam session, but you can expect lots of fun that can last up to three or four hours. Everyone is welcome inside the barbershop. (Society relaxed that whole "no women allowed in a barbershop" policy years ago.) They have a small selection of instruments lined in a row at the entrance, so choose your weapon and jump in. Cases are stored in a special berth near the circle of chairs where you can sit and play. Newspaper clippings and random items of clutter hang crooked on the walls or slump in mid-topple along the barber's shelves. Hot lather and jars of blue Barbicide fill the air with perfume while music from the mandolins, guitars and banjos wafts along too. Some of the instruments you'll see sitting around are even for sale. It's a music store, it's a barbershop, it's a jamboree!

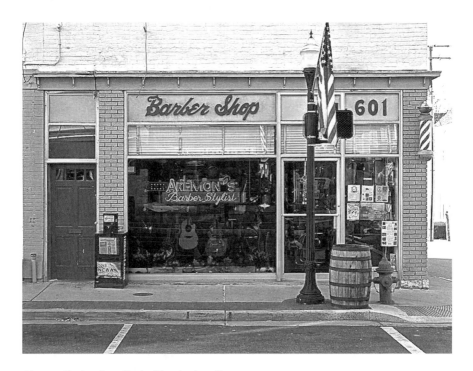

Akemon Barbershop, Paris. *Photo by the author.*

Play along or just sit back and listen to bluegrass, mountain and/or folk music. The outside traffic and occasional tractor rolling slowly down the Paris, Kentucky Main Street will put you in mind of Mayberry USA. The only things missing are Floyd the Barber and Barney. American flags wave from the windows of local businesses in an area reminiscent of our nation's glory days. Classic American music floating from the barbershop into this Norman Rockwell scene of small-town bliss just completes the picture. Come listen and just breathe it all in...but not too close to the Barbicide.

The good people at the Akemon's Barbershop Jam are always looking for singers and pickers, so tell a friend before you come on down. And in case you were wondering, yes, the Akemons are related to Bill Monroe's famous Kentucky banjo frailer and *Hee Haw* legend David Akeman, aka "Stringbean" (1916–1973).

Contact Ed Buhler (859) 576-4977. 601 Main Street, Paris, Kentucky.

CONWAY MUSIC BARN AND THE BLACK BARN
CONWAY, ROCKCASTLE COUNTY
MIDWAY BETWEEN BEREA AND RENFRO VALLEY
FRIDAYS AND SATURDAYS, 7:00 P.M.–MIDNIGHT

What a setting—cowboy hats, wagon wheels, a dirt floor and bluegrass music. Colored lights chase along the rustic wooden walls where horse bridles, saddles and assorted tack hang as decorations. The bands, either the Conway Express or Rhinestone, twang from the stage from behind the rugged wooden cattle gate. The place looks like an old press photo from the classic era of radio jamborees. Why, you almost expect Jimmy Wakeley, Joe Maphis or Gene Autry to emerge from the shadows to join in. If only they could, as guest singers are welcome to assume the stage and belt out a few.

If you like dancing, this is your place. Kick your feet up, either in the air or on the table, as you revel in the sights and sounds of the Conway Music Barn. You can also relax knowing that places like this are dutifully carrying on the traditions and heritage of the hills. The Berea/Renfro Valley area is all about that anyway. Once you get a taste, you'll want to return again and again.

In fact, upon my second trip to Conway, the festivities that were once held at the Conway Music Barn had moved across the railroad tracks to another venue...the Black Barn. This lofty structure has been hosting bluegrass

jams intermittently for the past thirty years. I brought my harmonica to the show, signed the guest sheet and waited my turn on a church pew. The raw wooden walls are adorned with the usual flags and bunting. Faded Polaroids of families and friends are stapled to the walls in haphazard montages, while rusty rabbit traps dangle from chains nailed to timbers. There are red lanterns and purple strands of Christmas tinsel, mismatched furniture and dim lighting. People ambled freely about, getting up to chat or to step out for a smoke. Guest singer David Matthews from Sevierville, Tennessee, sang classic country tunes, while fiddler extraordinaire Joe Cope sawed away. Every fifteen minutes or so, the deafening rumble of a passing freight train would drown out the band. Somehow, it just made the experience better.

The country drawls were thick, hoarse and twangy. Laid-back southern humor was traded back and forth from the audience to the stage, and with each homespun turn of a phrase, I felt like I was getting one last glimpse at America's lost authenticity. It was all very bittersweet. (My ability to experience the remnants of these fading traditions is what keeps me driving from town to town, and it's why I have committed myself to this project. I believe I belong to the last generation who will experience this kind of honesty firsthand.)

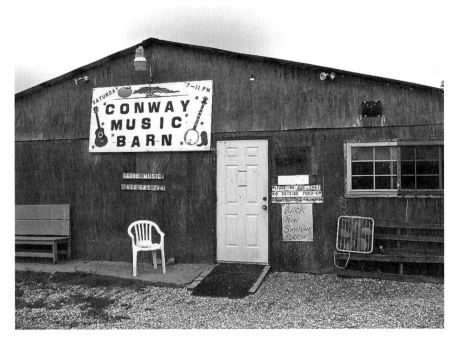

Conway Music Barn. *Photo by the author.*

Suddenly, my name was called, and it was my turn to assume the rickety Black Barn stage. The bandstand, a wobbly structure strewn with cables and mismatched carpet samples, stands wide yet shallow and about three feet tall. I joined the pickers and played "I'll Fly Away" and "The Old Home Place" to a good amount of applause. A few words of gratitude were spoken over the mic, and the show was at last over. I shook some hands and explained who I was and what I was doing. They told me about their plans for a fundraiser to help keep these barn shows going. When I suggested they post an announcement on *the Internet*, I was met only with silent stares. I quickly changed the subject and told them more about my book, to which they responded, "Well, we want to get a copy when it comes out!"

The concession stand serves Pepsis, Sprites and coffee, maybe some chips. Unfortunately, the only "facilities" at the barn is an outdoor port-a-john, so if you get nervous before performing, you might want to keep that in mind.

Nope, the place ain't fancy, but the music is great, the folks are nice and, as one online reviewer put it, "sometimes it isn't about how nice a place is, it is about how welcome you feel when you throw down your money."

If you are one to cut a rug, the Black Barn has a big dirt dance floor, and there's plenty of free parking. So come to the show with a truckload of dancing partners. The cover to get in is free.

GOLD DUSTER
CONWAY, ROCKCASTLE COUNTY
SATURDAYS, 7:00–11:00 P.M.

Folks really come out in droves to dance at the Gold Duster, that giant pre-fabricated metal building in Conway, Kentucky. Heading from Renfro Valley, you'll spot the flashing-arrow marquee just past the old yellow Conway Music Barn sign. Chasing lights, plastic letters and poster board are lashed to the marquee panels with extreme amounts of clear packing tape. The Black Barn is almost directly across the street, posing a conundrum to the tourist. Which place to visit first on a Saturday night at seven o'clock?

I must admit, the rock 'n' roll sound check emanating from the Gold Duster lured me in first. I was early to the show, but I paid my five bucks to one Mr. Joe Shelton, the club owner. He was kicked back at his station in the entrance way. His face was tan, and his eyes were locked in a perma-squint, no doubt the result of years of hard work in the heat. The sunlight through

the door sieved through the holes of his wicker gardening hat, creating a thousand points of light on his face and a photo op I wouldn't dare take advantage of. Once inside, I heard the inside jokes he traded back and forth between each neighbor who happened in next. Eventually, a slew of local music fans had piled in by the scores, duded up like cowboys, bikers or "just folks"—and all of them in the mood to dance.

I would describe the place as a cross between a Texas "boot scoot" and a Tennessee opry show. However, the line dance and clogging scene in Conway is 100 percent Kentucky. At the Duster, no one drinks anything harder than coffee (at least out in the open), so the venue keeps with the jamboree tradition of a wholesome family environment. That said, they do allow smoking. In fact, if you don't smoke, you might end up dying from second-hand emphysema on the spot. Personally, I think the smoky air just makes the experience better. Kentucky is Tobacco Country after all, dammit.

The décor at the Duster is a veritable hodge-podge of rustic whatnots. Black velvet paintings, yard sale art, dreamcatchers and miles of chasing

Gold Duster marquee, Conway. *Photo by the author.*

lights bedeck the pine lumber walls. The wood comes from the timber harvested and milled by the Shelton family themselves. The place has a great vibe, and I would have taken more pictures, but I didn't want to make people too self-conscious. Far be it from me to kill the buzz.

Music was supplied by the cover band Hot Pursuit, who played hits by the Osbourne Brothers, Wilson Pickett and Creedence Clearwater Revival—anything with a catchy melody and a danceable beat. They were tight and had great harmonies.

Come as you are to Conway, but when you do, be sure to bring a dime. You'll need it for the coin toss to determine if you're going to the Gold Duster or the Black Barn. Either way, you'll have a blast.

HORSE CAVE'S JAMMIN' ON THE PORCH
HORSE CAVE, BARREN COUNTY
THURSDAYS, 5:30 P.M.

In the lush summer months, downtown Horse Cave sits lazily nestled in the idyllic glory of Barren County. However, buildings that once housed downtown grocery and hardware stores are now home to tattoo parlors and "head" shops. Despite the classic, small-town architecture, I couldn't help but be reminded of that sad alternate universe where "Bedford Falls" is known as "Pottersville." What a shame that it has come to this. It truly seems that my own *lazy* generation is perfectly content to squat in the achievements of our grandparents. Perhaps that is why I am on this quest. It's my miniscule way of giving back.

Across the street from the quaint, turn-of-the-century brick building *that sells bongs* is the Thomas House. This is the home of Jammin' on the Porch, a long-running weekly jam session, and a place where you will find the "good ole days" again. The Thomas House sits at the entrance to Hidden River Cave and is surrounded by calming, natural bliss and beauty. As you walk along the left of this two-story Victorian showplace, you will begin to hear the strains of fiddles, guitars and spoons ringing out. Twelve-string guitarist Stan Blanton has been running this porch jam for a year and a half, having taken over from the last guy. His buddy Bill Justice often accompanies on guitar or fiddle and cracks the occasional joke or two. People from all around the Mammoth/Horse Cave area meet here to "jam on the porch." Many of them are visitors from the surrounding campgrounds.

"We're mostly all local, but a few out-of-state folks will come from time to time," Blanton told me. "We had a group of kids from Michigan here last year. There were fifteen or sixteen of them!"

Blanton gives banjo and guitar lessons on the side and "tries to keep the music going with young people." And that he does. Upon my visit, there were three teenage pickers hanging out with all the "old folks," learning the classics. Thirteen-year-old Alex Napier favored us with a country tune, picking the lead and singing perfectly, just like it was done on the record. He likes playing along on the spoons to other folks' tunes too. One young man, who wanted to be identified by his stage name, "Butchhawk Hank," says he enjoys plucking the banjo and that I should check out a picking party called MurphFest in Bowling Green.

Originally, the Thomas House was a humble structure, but in 1897, George A. Thomas converted it into a giant Queen Anne–style home. Thomas was the clever fellow who used the nearby underground river to furnish water to the community. He even installed a generating system that made Horse Cave the second electrically lit town (after Louisville) in Kentucky. Tourism

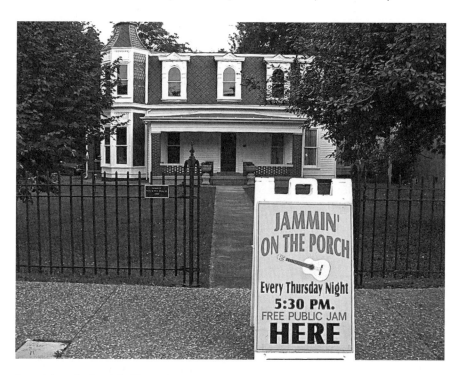

Jammin' on the Porch in Horse Cave. *Photo by the author.*

in the Horse Cave area boomed when his son, Harry, inherited the house and opened up Hidden River Cave to campers, sightseers and spelunkers.

These days, the Thomas House is a community space that is kept by the City of Horse Cave. It also shelters the jam during inclement weather. The interior central stairs, fireplace and corner cupboards remain faithfully intact, while other parts of the house have been restored to spec. During my visit, an awe-inspiring sunset settled over the cave-side proceedings. Birds chirped in the canopy while the dulcet tones of Blanton and company upheld my hope for the area's culture. As long as he can encourage the next generation to respect their hometown, its history and traditions, the Thomas House will continue to be a haven among modern-day "signs of the times."

Haywood Music Barn
Haywood, Barren County
Every Saturday from first week of November
to mid-April (Closed Christmas)
Second Saturdays from Mid-April
to end of October

In a semi-rural suburb of Glasgow, Kentucky, there sits an unassuming, vinyl-clad garage beside a house. It's the Haywood Music Barn, a place where Patty and Calvin Melton have hosted area bands, fans and pickers for the past twenty-one years. One peek inside the windows and you'll know you're in the right place. Within the sixty- by thirty-foot dimensions of this large-scale outbuilding is a thirty-foot stage that hosts some of the best music offered in the Horse Cave, Haywood and Glasgow area. All around the room hang wooden panels "for acoustics" and thousands upon thousands of colored lights. Above the stage are displays of old musical instruments, a three- by six-foot American flag and signage that heralds "Country. Bluegrass. Gospel."

"That's all we play," says Melton. "I hate all that folk music and what I call 'long-hair music,'" he continues. Apparently, this suits visitors just fine since Melton is proud to have "had thousands of people visit from all the states but five." Pretty impressive for a garage outside Glasgow, Kentucky.

There is a no-smoking policy inside, but snacks and drinks are allowed if you want to bring your own. No alcohol, profanity, "dirty dancing" or other philistine behavior is allowed either. The atmosphere is family friendly; in

fact, you, too, will feel like part of the "family" of musicians and music-lovers who attend on Saturday nights.

Doug Jones and his band Real Country perform band duties at the barn. *Steel* Country, the former barn band of eight years, has moved on, as have several bluegrass groups that launched from the Haywood Music Barn. According to Melton, the youngest to ever play his stage was an eight-year-old boy. The oldest was eighty-five. One child prodigy, Luke Vaught, got his start on the barn stage at fifteen and went on to join the gospel group the Inspirations. According to legend, Vaught was so good that they rebuilt the entire show around him when he joined the band.

"He could take a fiddle that's out of tune and play it *in* tune. His mind knows how to correct it," Melton beamed. "And I discovered him!" Other regulars include those who've played behind Kenny Chesney and Earl Scruggs.

When I asked Melton why he started the jam in the first place, he replied, "It was an accident!" He didn't realize he was starting anything up since originally it was just an impromptu jam inside his house. Some of his pickers had expressed an interest in playing in the outbuilding where Melton had been constructing trailers. The place was all messy and covered in dust, but Calvin conceded. He vacuumed it out and let them in. "That was the second Saturday in August 1992," said Calvin. "We've been going twenty-one years since!"

The barn is the perfect extra activity for those visiting nearby Mammoth Cave. Turn next to the Scrapbook Village. It's a little ways down on the left, 262 Haywood Cedar Grove Road, Glasgow, Kentucky. It's a nice neighborhood actually.

"Nobody understands how I can get away with it!" Melton proclaimed. He's right. One wouldn't necessarily expect a country music show to take place among all the well-groomed residential lots. "We put a sign out every Saturday evening," Melton said. So keep your eyes peeled and come prepared for a good time in a nice family-friendly place with free admission. But call ahead if you prefer: (270) 646-6023.

> ## SHEPHERDSVILLE MUSIC BARN
> ### SHEPHERDSVILLE, BULLITT COUNTY
> ### BLUEGRASS FRIDAYS, COUNTRY SATURDAYS

Every weekend, the Reid family hosts their "Best in Bluegrass" music show inside the good ole, down-home, Shepherdsville Music Barn. For years,

big-name acts in the biz have backed their buses to the dock to load in for a Friday night show. Acts like the Grascals, Whiskey Bent Valley Boys, Doyle Lawson, Josh Williams, J.D. Crowe and Ralph Stanley, plus many more, have graced that old wood-plank stage. The program is also broadcast on the *Monroe's House of Bluegrass* show on 1320 AM WBRT (and on www. wbrtcountry.com).

Saturday nights feature a variety of country, oldies, rock 'n' roll, comedy and gospel shows. It's important to phone ahead or check the website to see what the theme of the evening will be. Regular admission is eight dollars, or seven dollars for senior citizens.

The cinder block building sits off the highway a bit, allowing for a very large parking lot and loading zone for tour buses. You can't miss it. There are three, count 'em three, signs out front to catch your attention. There's a red barn-shaped one, a *shack*-shaped one with a little shingled roof and a classic "blinking arrow" marquee, complete with chicken wire to protect the removable plastic lettering. (I'd like to see those teenagers try to rearrange the letters now, dad-nabbit.)

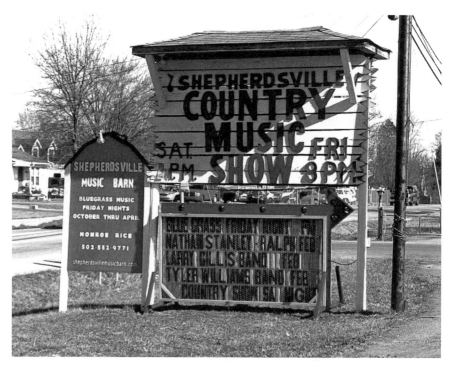

Shepherdsville Music Barn. *Photo by the author.*

As you walk in, you'll find that the auditorium is deceptively immense. Plush oxblood theater seating awaits you within the darkened halls. The stage is tall, deep and wide and continues the red-and-white barn motif begun by the outdoor signage. The large white lettering above the stage reads "COUNTRY MUSIC," while guitar shapes and musical notes adorn the proscenium. Silver foil stars flank the drum riser, which is centered against a *Grand Ole Opry*–style red barn backdrop. The barn doors even have those white X cross-arms, like a Fisher-Price farm toy. The faux-ramshackle walls and ceiling are warped, wooden slats (perhaps cedar) varnished to highlight the warm hues of the space. Golden lights illuminate the stage, where music stands and monitors sit akimbo. This is perhaps the most aesthetically perfect rendition of a barn dance stage I've seen yet.

There are snacks and drinks available up front. While you're waiting in line, check out the Wall of Fame that features 8x10 glossies of all the stars who've come before. The place really has the feeling of an old-time barn dance or an old *Town Hall Party* broadcast. It's like a hayride had a baby with *Hee Haw*!

Call (502) 297-9979 or go to www.shepherdsvillemusicbarn.com for more information. The barn is located just three miles west of I-65 from Exit 117, 1833 Highway 44 West, Shepherdsville, Kentucky.

TONY'S BBQ BARN
LAWRENCEBURG, ANDERSON COUNTY
MONDAY NIGHT JAMS

Tony's BBQ Barn has been open since January 2003. "Tony" himself takes pride in the great family atmosphere he has created beneath the big red barn roof. He and the crew serve barbecue and other mouth-watering morsels of down-home cookin' like "Bearcat Wings," "Cheese Teasers" and "Bowl Hocks." Bluegrass music is served on Monday nights while you sit, tapping your toes and stuffing your face. Sounds like an amazing Monday to me.

Everyone at the BBQ Barn works very hard to ensure an awesome experience for their customers. That's Tony's pledge—to you. In fact, Tony's famous "Kentucky Proud Burgoo" is a highlight of the Bluegrass and Burgoo Festival at the Water Tower in Louisville and was served at the 2012 Rolex Games at the Lexington Horse Park. This mouth-watering meat feast has even graced both the Kentucky State BBQ Festival in Danville and

the Anderson County Burgoo Festival. Tony himself was featured on the History Channel's *Redneck Road Trip*, sharing his secret recipe for making burgoo: three smoked meat flavors with a variety of vegetables and great seasonings. This is the kind of food that goes best with bluegrass music.

After local musician James Webb discontinued his jam at the Frankfort First Baptist Church, the BBQ Barn helped pick up the slack, providing an outlet for displaced local bluegrassers. The place is hard to miss, what with all its shabby-chic trappings: rocking chairs, barn quilts, campy signs and such. Once you're on the inside, oak booths welcome you into a cozy corner where the walls look like they're made from raw hickory or mesquite. Spindle-back chairs, kitschy wall hangings and gingham curtains combine to make this a classic barbecue joint. Just look for the giant gambrel roof in the clouds, towering like a rural wooden skyscraper. You'll find it.

Call ahead by dialing (502) 859-3030. Tony's BBQ Barn is located at 1435 North 127 Bypass in Lawrenceburg, Kentucky, and on the Internet at tonysbarn.com.

> SOUTHLAND JAMBOREE
> COLLINS BOWLING CENTER (OUTSIDE)
> LEXINGTON, FAYETTE COUNTY
> SUMMER MONTHS, TUESDAYS, 7:00 P.M.

During a civic meeting in 2005, folk singer Michael Jonathon (of Lexington's *Woodsongs*; see listing) suggested that the city of Lexington had "an unrecognized art form in bluegrass music." As a result, the Southland Association Board of Directors decided to provide ongoing outdoor bluegrass concerts for Fayette County residents. The concerts were to feature top local and regional bands and be free to the public. The Southland Association quickly became equal partners with Parks and Recreation for the purpose of presenting this new Southland Jamboree.

Folks everywhere are invited to gather around that rugged wooden stage. Large-scale loudspeakers perch on aluminum tripods, flanking the old pine planks. Green grass and a lush canopy of summer growth visually "pop" against the orange jamboree banner. Remember to lug along a lawn chair and a blanket because when the wind blows just right on a sunny day, the music somehow just sounds all the better. Post-concert jams often break out randomly, so jamboree planners invite you to bring along your own instrument of choice. That's when the real soiree begins.

In the case of a rainout, the event coordinator will post cancellations on the Southland Jamboree Facebook page by 6:00 p.m. on the day of the concert. But why not bowl a few frames if you've already driven out? All surrounding merchants allow free parking for jamboree attendees.

205 Southland Drive, Lexington, Kentucky. For jamboree information, contact Phil Wyant at (859) 276-4692.

OTHER EVENTS

Jam at **Aunt B's** at 8368 State Road 64, Georgetown, Kentucky, every Monday 6:00–9:00 p.m.

Jamming at the **Bluegrass Music RV Park**, year-round in Franklin, Kentucky

Bowling Green KOA Campground bluegrass jam every Thursday night

Saturday night dancing at **Felt's Music Place**, Corbin, Kentucky

The Firehouse Pickers, 6:00–9:30 p.m. (or so) on Tuesday and Saturday evenings at Crestwood Christian Church, 1882 Bellefonte Drive, Lexington, Kentucky, 40502. For more information, call Abbott Little (859) 271-6050.

Leitchfield Open Jam and Show at the Rough River Dam State Resort Park Lodge, second Friday each month, 6:00 p.m. (270) 617-1152 or (270) 617-0478

Lexington Irish Jams:
Goshin's Tavern, 1803 Alexandria Drive
O'Neill's Irish Pub, 2051 Richmond Road, Suite 140
Pie Bar (formerly Brooklyn Pizza), 410 West Short Street, downtown
Tee Dee's Bar, downtown, corner of Elm Street and Second Street

Old Gospel Barn, Bardstown, KY

Pickin' in the Park at the Old Mulkey Meetinghouse State Historic Site, third Saturday each month, 6:00 p.m. in Tompkinsville, Kentucky. (270) 487-8481, www.parks.ky.gov

Russell's Shed, Steel Guitar Club meetings, Shepherdsville, Kentucky

Sutton Ole Time Music Hour (Granville, Tennessee), broadcast over WTKY, Tompkinsville, Kentucky

Vine Grove Bluegrass Jam, Vine Grove, Kentucky. Winter jams: Vine Grove City Hall, 300 **West Main Street Summer Jams**: Optimist Park, Vine Grove

Willie's Locally Known, Mondays at 7:00 p.m., Lexington, Kentucky

LOUISVILLE AND NORTHERN KENTUCKY

JUG BAND CAPITAL OF THE WORLD

One of my earliest recollections is the ride I took down the Ohio River on deck of the *Belle of Louisville*, circa 1976. This former Memphis cargo ship, once named *Idlewild*, survives as America's last true Mississippi River steamboat still in operation. The *Belle* turns one hundred years old in 2014, so just imagine the music she has witnessed during her century afloat. And the music she herself has made with her own steam-fed calliope still echoes in my memories of youth.

At the turn of the twentieth century, the Derby City was bustling with the sounds of such calliope notes—along with guitars, tambourines, French harps and whiskey jugs. That's right. Whiskey jugs. Thanks to Kentucky's long association with bourbon, these pot-bellied pitchers of pottery abounded statewide. Singer Earl McDonald (circa 1885–1949) discovered that a burst of air across the lip of a jug could create a bass note. This was the perfect addition to those other spanky instruments of the ragtime era. By the spring of 1900, jug bands were forming and jug tunes were delighting the citizenry (and scaring the horses) on the streets of this fair river city.

Yes, jug band music was literally off to the races. Kentucky Derby fans first heard McDonald's now-legendary Louisville Jug Band in 1903, and jug band music has become an annual tradition at Churchill Downs ever since. McDonald also served as the bandleader for the Ballard Chefs Jug Band for three years. Their broadcasts over WHAS in the late 1920s were an instant hit with listeners. Up and down the rivers, riverboat decks resounded with

folks thumping, strumming and scraping on common bits of household miscellany. The wacky, infectious rhythms of scrub boards, washtubs and jugs were also serenading the home listener on 78rpm records. Jug tunes were printed as novelty sheet music for the home performer and were fast becoming prevalent at medicine shows across the South. But always remember, the birthplace was Louisville, Kentucky.

Although the craze died out around World War II, the music is still popular among retro-minded hepcats all across the country, Europe and the world. John Sebastian of the Loving Spoonful made the genre known to baby boomers. Gen-Xer Leroy Troy and the Tennessee Mafia String Band perform the style on Marty Stuart's *RFD* television program. Bands like the Asylum Street Spankers (from Texas) and Pokey LaFarge and the South City Three (from Missouri) play jug music to hipper, younger crowds worldwide. Pokey is even helping revive the 78rpm format by recording new music on old-style acetate discs.

In 2008, Japan's Old Southern Jug Blowers released the album *The Jug Band Special*, a tribute to the 1920s recordings of Earl McDonald. In fact, an entirely modern, bastardized redux of jug music abounds today in Japan. It's a trend called "Rustic Stomp," where Japanese hipsters joyfully misinterpret the art form using homemade instruments and modern gadgetry. The power of Kentucky's musical ingenuity persists into the twenty-first century!

THE TILLERS

There is one contemporary American band that combines the jug influences of Louisville with the mountain music of northern Kentucky. That band is the Tillers, my favorite group in all of Kentucky (although they are based mostly out of Cincinnati; close enough). Members Mike Oberst, Sean Geil and Aaron Geil are the perfect conduits of the mountain and river cultures. Their geographically central location in the Cincinnati/Covington area explains their aptitude for both styles. They not only frail banjos like mountain men but also wail on harmonicas and kazoos to get that old jug band sound.

If you ever get the chance to see them, please do. They are almost single-handedly keeping the old-time square dance traditions alive in both northern Kentucky and southern Ohio. I asked Oberst and his friend Judy Waldron (of the Rabbit Hash String Band) for some extra insight into the northern Kentucky old-time circuit.

J.D. (right) outside Earl's.
Photo by Roman Titus.

Earl Butler's gut-bucket
bass, Olive. *Photo by the
author.*

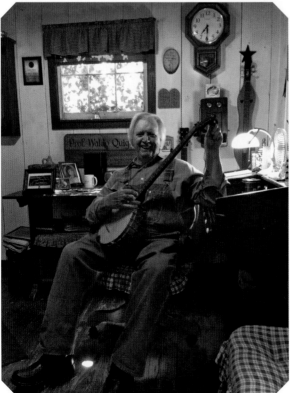

Above: Earl Butler outside his jamboree building. *Photo by the author.*

Left: Scottie Henson inside his cabin near Benton. *Photo by the author.*

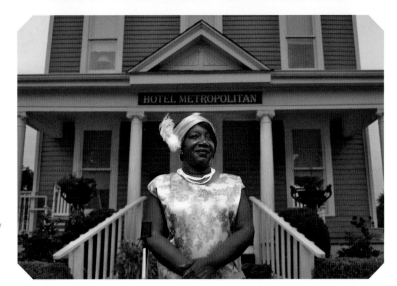

Betty Dobson outside the fabled Hotel Metropolitan, Paducah. *Photo by John Paul Henry.*

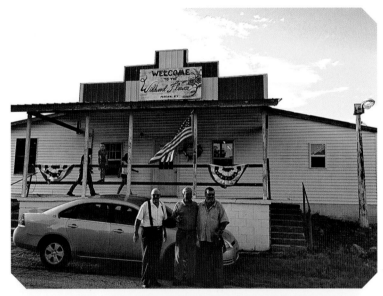

The Wildwood Flower Square Dance, Magan. *Photo by the author.*

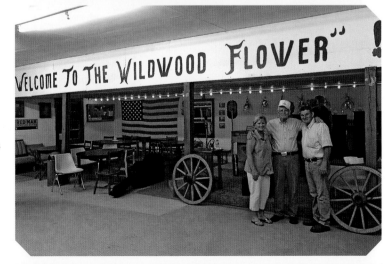

Elvis Doolin (far right) with friends and family at the Wildwood Flower Square Dance, Magan. *Photo by the author.*

Bobby Anderson Stage, Powderly.
Photo by Carey Gough.

Porch jam at
Woolsey's General
Store next to
the Rosine Barn
Jamboree. *Photo by
Carey Gough.*

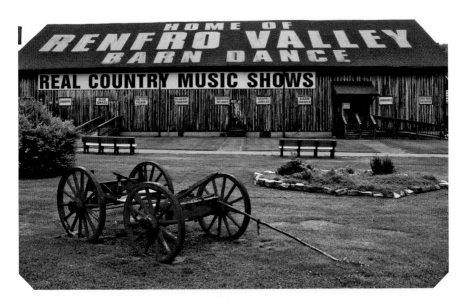

The famous Renfro Valley barn. *Photo by the author.*

The Burgin Barn. *Photo by the author.*

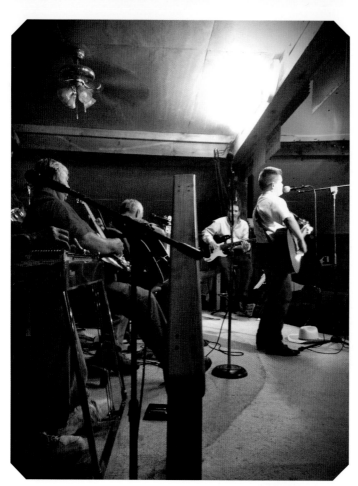

Left: "Li'l Hank" singing at the Burgin Barn. *Photo by the author.*

Below: The Rosine Barn Jamboree. *Photo by Nathan Blake Lynn.*

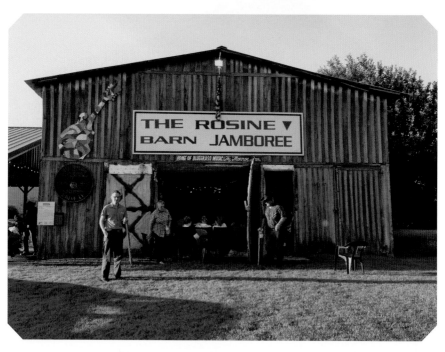

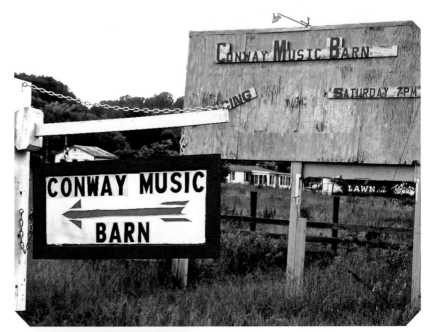

way Music
n sign. *Photo by
uthor.*

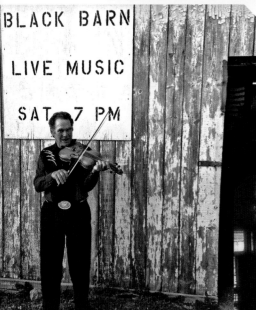

Fiddler Joe Cope at the
Black Barn, Conway. *Photo
by the author.*

Outside the Gold Duster,
Conway. *Photo by the author.*

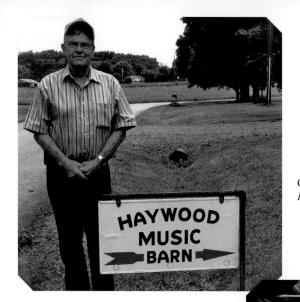

Calvin Melton outside the Haywood Music Ba[...]
Photo by the author.

The famously haunted Bobby Mackey's in Wilder. *Photo by Carey Gough.*

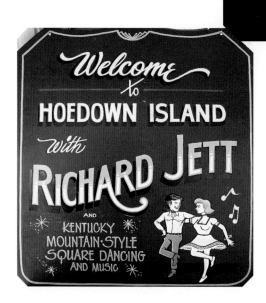

Richard Jett's Hoedown Island plaque, Powell County. *Photo by the author.*

According to Mike, his favorite picking parties are at Newport's Southgate House Revival and Molly Malone's in Covington, Kentucky. However, as I might have expected, he has a special place in his heart for Rabbit Hash, Kentucky. And if you've ever been there, you know exactly what he means. (More on Rabbit Hash in this chapter.)

On the subject of northern Kentucky dances and their history, Oberst knows only of a series of barn dances throughout the summer in Rabbit Hash and one in Louisville. Evidently, there aren't any "squares" yet in Newport or Covington, but the Rabbit Hash String Band and Oberst have organized a now-popular square dance held every second Tuesday at the Northside Tavern, just over the river in Cincinnati.

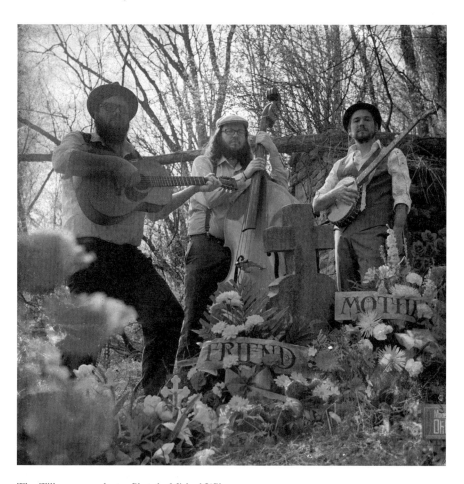

The Tillers press photo. *Photo by Michael Wilson.*

Judy Waldron and her band mate Russ Childers recollect seeing a primitive square dance at the Kinkaid State Park about twenty years ago—one complete with live music and a caller. "There also used to be dances at R.C. Vance's place just south of Burlington," Waldron remembered. "We sometimes played music for them."

The Verona Lake Ranch in Boone County was a famous hot spot for hillbilly music, featuring top acts like Flatt and Scruggs and Little Jimmie Dickens throughout the 1950s. In the mid-1980s, Mike Noll's place in Covington, Kentucky, had old-time square dances, complete with live music. Childers has also heard rumors of an ongoing square dance that takes place somewhere near Goforth, Kentucky. (What a neat idea—a secret square dance that may or may not be surviving somewhere in the backwoods of Kentucky!)

Just for fun, I quizzed these experts on which Kentucky players were dearest to their own hearts. Oberst chose banjo pickers Lee Sexton, Morgan Sexton, Roscoe Holcomb, Banjo Bill Cornett, Buell Kazee, Pete Steele and Ballard Taylor. Judy simply chose Roger Cooper, an important living Kentucky fiddler. You'll find that the northern point of the Bluegrass State is no different than the rest of the Commonwealth when it comes to the importance of fiddle music. Waldron also points to the repertoire played by Doc Roberts, which contains many a tune unique to their area. "Big Scioty," "Martha Campbell," "Briarpicker Brown" and "Catlettsburg" have special relevance to northern Kentucky.

Oberst, Childers and Waldron agree that the late great fiddler Tommy Taylor is the most important figure in the northern Kentucky old-time scene. Oberst routinely visited Taylor in his room at the nursing home, hoping to capture some last glimpses into his storied past. Taylor was a fan and friend of Georgia's Skillet Lickers and patterned his playing after their style. He inspired the formation of the Rabbit Hash String Band, a group that Waldron and her husband carry on to this day.

"T Claw"

I also had the distinct pleasure of discussing Kentucky's square dance scene with twenty-seven-year-old traditional square dance caller T Claw. That's right, just "T Claw." For such a young man, he was incredibly knowledgeable about square dancing, not just in Kentucky but worldwide. His journey into

the world of "squares" began in Olympia, Washington, where he had been playing music. He happened upon a dance in Portland, Oregon, and it all "just clicked."

"I liked the social aspect. It was all about community," he told me. "I started dancing, but there wasn't a live caller. So I learned how to do it. But that's the way it is in a lot of places," he said with a hint of melancholy. T Claw says he is currently the only active square dance "house caller" and organizer in both Kentucky and Tennessee. There are still callers that are active, but due to age and lack of interest, they're not as available anymore.

Currently, he calls his dances at the AmVets post in Louisville. In the next six months, he plans to start a "How to Create a Dance in Your Town" model so the tradition can spread. One aspect of his dances is the prevalence of live, old-time music. It is what sets him apart from other events. He reckons that about 99 percent of modern dances use recordings.

"You gotta have live music; you gotta have a fiddle!" T Claw's friends the Tillers play at the aforementioned Cincinnati square dance, another one of his new dances from the past year.

Anywhere from 75 to 150 people regularly attend the AmVets square dance in Louisville. Not too shabby if you consider the challenges old-time traditions have had to overcome in modern times and metropolitan areas. "We're doing good if we are getting a hundred people," he explained. "Then I can give a decent guarantee to the band."

T Claw has found that Facebook is a useful tool that provides free advertising and marketing. "[If we can] grab those e-mail addresses from the folks, that's how these dances will thrive into the future," he explained.

It seems ironic to use social media to promote such an old-fashioned art form, but it's necessary to "hip things up" and stay connected with the kids. Square dancing was huge in the 1940s and '50s. And another wave came in the 1970s. But, according to Claw, upon its second resurgence, it seemed to serve a different purpose. In a postmodern era divorced from its community spirit and other fundamentals, the square dance morphed into a regimented exercise of memory skills. Among most practitioners today, it has come to mean "a dance community's dance."

"Traditional dances," explained Claw, "took a hit from the 'dance geeks' who don't care as much about community, fellowship or the potluck. They are only interested in learning complicated modern moves."

T Claw's model embodies the spirit of the original, 1920s-era square dance. Throughout the twentieth century, squares came to be called

T Claw and his band, Trappers Keepers, at a Louisville square dance. *Photo by the author.*

"western dances," and callers began to one-up one another with increasingly complex calls. Unfortunately, this is part of what has led to contra dances or Modern Western dances being what they are in most cities today. T Claw also believes that the stigma the term "square dancing" suffers from came from how it was thought to be a "country" or "Appalachian" thing. "Maybe that has bad connotations with urban folks."

I can attest to this. Try showing up to play a banjo in front of a contemporary audience of urbanites or even urbanized southerners. In five minutes' time, you will hear some snarky joke about *Deliverance*, incest or racism. And nothing aggravates me more than the "ironic hoedown" dance, performed mockingly whenever some frat boy happens to see a banjo. It's very frustrating how we've been brainwashed to hate our own culture.

"Personally, I don't like using the term 'hoedown,'" Claw explained, "as if it were only about the South. I call it an 'old-time social.' I want people to feel comfortable, have dinner, maybe do some quilting even."

He continued, "It's not a dance 'performance,' after all. It's a get-together! I want [the dance] to be really welcoming to the people who might be afraid of the sound of a 'square dance.'"

T Claw stated that he is not opposed to including a line dance or a contra dance, but because his square dance is such an unrivaled hit, he wants to keep it distinct. Two-steps, schottisches and waltzes just help add variety to his Louisville "old-time social."

Regarding the evolution (or devolution) of culture and dance, T admits that television and technology have affected things too. "Calls changed with the invention of the microphone. It went from hollers and whoops to more poetic, musical and rhyming tones. Kind of like an auctioneer."

But, as he explained, there is a new trend "to make things look old." Indeed, a "shabby chic" aesthetic has taken hold in some contemporary corners of America, where people use roughed-up leather and wood and other organic elements to mirror our humble human essence. Small-time organic farming has caught on as a hip movement among those who wish to become more self-sufficient.

T Claw speaks from personal experience: "Guys in bands discover they're not satisfied with modern music, so they pick up an acoustic instrument and just sing songs." This phenomenon is what I like to call the "Punk Rock Retirement Plan."

Despite some encouraging trends, the future of traditional square dance "socials" across Kentucky is currently unclear. T would like to see Berea have a regular dance again, which it is currently working on (see listing). What is more common now are square dance *clubs*. To participate, one must have a partner, take lessons and pay a fee. This is mostly an over-sixty crowd (not that there's anything wrong with that), but the emphasis is on complicated figures walked at a snail's pace—similar to the aforementioned contra dance.

"Every dance is a mandatory four couples," T Claw said of square dance clubs. "But we have two-couple, three-couple and four-couple squares doing traditional figures." This is how it used to be.

Flash-forward to today, and it is Washington, D.C., oddly enough, that has the biggest traditional square dance community. As it turns out, there are tons of old-time musicians and dances in our nation's capital. The combination of urban, "retro chic" and Virginia traditions has met with perfect results. Three to four hundred people show up every couple of months to don their duds and swing their partners.

"There's not a lot going on in the South," mourned Claw. "There are some in Alabama and some in Durham, North Carolina. Portland, Kalamazoo and other midsize cities up north have regular dances. The last and longest-running continually going square dance is in West Virginia."

Louisville square dance. *Photo by the author.*

T Claw taught a workshop in Morehead recently where the locals picked up enough to start their own dance. I have mentioned the Wildwood Flower Square Dance, and I will report on the Carcassonne and Hoedown Island square dances in my chapter on eastern Kentucky.

However, it is northern Kentucky folks like the Tillers and T Claw who bring a fresh, hip take to old-time traditions, defibrillating a scene that

has grown stale and predictable. I find it strange how such basic human expressions like music and dance have descended into rigid, competitive recitals. How an art form that involves "swinging girls around in a barn full of hay" became a robotic ritual set to a boombox is anyone's guess. I reckon sometimes you just need some ornery outsider to come kick down the doors and wake everybody up. Enter the Tillers and good ole T Claw from northern Kentucky.

> ### KENTUCKY HOMEFRONT
> CLIFTON CENTER
> LOUISVILLE, JEFFERSON COUNTY
> SECOND SATURDAYS (EXCEPT JANUARY AND JULY)

Kentucky Homefront is a radio program carried over WFPK-FM that features Kentucky's best acoustic folk, traditional, blues, country and bluegrass musicians, and storytellers too. Like *Red Barn Radio* and *Woodsongs* in Lexington, *Kentucky Homefront*'s broadcasts are reminiscent of the radio jamborees of a bygone era.

Hosted by John Gage, *Kentucky Homefront* happens the second Saturday of every month (except January and July). The show is recorded before a live audience at the Clifton Center in the heart of the Frankfort Avenue section of Louisville.

Kentucky Homefront's mission statement declares that its intent is "to preserve, promote, and celebrate live grassroots music and storytelling traditions of the rich and diverse cultures of Kentucky and its surrounding states." It also believes that "the front porch is a gathering place for friends...where strangers become friends" and "a place for sharing and creating traditions." However, there are two guidelines for any acts wishing to play: you must have talent, and you must be from Kentucky or the surrounding states of Ohio, Indiana, Tennessee or West Virginia.

The show's host, John Gage, is an Oklahoman who is now based in Louisville. He is a well-known songwriter who has made a career entertaining audiences while singing and flat-picking his guitar. His music is described as an "alchemy of ancient balladeers and poets, transporting listeners inwardly for reflection and intimacy with others in the room." Sounds like he and Michael Jonathon of *Woodsongs Old-Time Radio Hour* should meet and have a sing-off!

Gage played clubs and bars for thirty years and had an okay time at it. However, at some point he realized he was just playing music while people were getting drunk. "I'd rather be playing on someone's front porch," Gage realized.

John went solo for years, playing and working his tail off. But all the while, he remained "poor as a church mouse." Before long, he and his friends were coming to the realization that they hated having to go to bars to hear live music. The dreary locales were a bummer, and the women were always getting hit on. So Gage, along with a couple friends, hatched the idea that would later become *Kentucky Homefront.*

"It just started as a conversation between frustrated 'serious listeners' of music," Gage recalled. "Next thing you know, Tom Donohoe from the public radio station said, 'You got a slot!' That was in 1983."

Gage and friends went on the air live for their first broadcast on a Saturday night, not realizing at first that they could have just prerecorded the show. But they pulled it off, and the show became a hit, growing and developing for the next ten years.

But when Bell South and AT&T split up, production costs skyrocketed 400 percent. That's because the humble phone line used to relay the program from venue to station fell under the ownership of a new utility. This marked the day the show would no longer be carried live. But that's okay. "I wouldn't want to do it that way again anyway," Gage admitted. Saving all that money allows John to pass more proceeds on to the artists.

With *Kentucky Homefront,* Gage has had the opportunity to break new, upcoming acts like IBMA "Flame Keeper" Michael Cleveland and the Bibelhauser twins of the band Relic. And to all the young upstarts, Gage offers this advice: "Polish your act!" As we all know, some folks in "the biz" simply just aren't ready yet. But Gage will work with young singers and bands, inspiring them to new heights. As a part-time pastor, John has served as a tremendous mentor to many people throughout his life, musicians and non-musicians alike.

Gage performs on festival stages throughout Kentucky and the region. He's also not above playing churches, libraries, schools or anywhere there might be an appreciative audience. As a veteran stage emcee, Gage has announced acts at many of the major festivals across Kentucky. He recalls his friendship with a young Sam Bush and Bluegrass Hall of Famer Art Stamper (1933–2005). According to both Bush and Gage, Stamper is credited as having helped influence the original bluegrass sound. Said Bush, "Art was from the first generation of fiddle players to combine old time music and mountain fiddling with the blues that was part of bluegrass."

The old fiddler insisted that John introduce all his songs. Gage remembers Stamper's "old man voice" crackling backstage after a show as he told stories about the good ol' days. Said Stamper about his early years, "We was making history and we didn't even know it!"*

Despite being diagnosed with COPD, heart disease and diabetes, Mr. Gage keeps up an intense schedule as a deejay, emcee, mentor, pastor, musician and all-around expert on Kentucky music. "I wanna die mid-stride," Gage laughed.

Touring from one end of the state to the other and beyond, Gage and I both have become aware of what he calls "the wealth we hold in common in the Commonwealth of Kentucky." We hope you'll join us too. The Clifton Center can be found at 2117 Payne Street, Louisville, Kentucky.

> ### Live Lunch Radio Show
> Louisville Public Media Performance Studio
> Louisville, Jefferson County
> Fridays, 11:30 a.m.

Every Friday afternoon, WFPK-FM (91.1 MHz) features the live music show *Live Lunch*, where downtown visitors and residents enjoy their lunch break and take in a show. For music fans, *Live Lunch* offers a great opportunity for them to meet artists up close and personal as they tour through the Louisville area. Many of these bands and acts regularly utilize the *Live Lunch* show to promote their other gigs around town.

The big broadcast emanates from Louisville Public Media's performance studio (LPM). Up to seventy-five people can be comfortably seated in the intimate listening room. The performance studio was specifically constructed in the year 2000 with live music performances in mind, which explains the terrific acoustics. In addition to WFPK-FM's tasty music format, Louisville Public Media also includes WFPL-FM, the local source for National Public Radio. And as is the case for most radio broadcasts these days, the programs are also streamed over the Internet.

Live music radio shows in Louisville follow the grand tradition set by clear channel blowtorch WHAS-AM. In the 1930s and '40s, WHAS broadcast

*. Art was the son of legendary fiddler Hiram Stamper, who is credited as "one of the last leading contributors to classic eastern Kentucky old time fiddling." His other son, eighty-one-year-old Charlie Stamper, continues to make music to this day in Cadiz, Kentucky, home of the Lakeland Jamboree. See listing.

the *Renfro Valley Barn Dance*, as well as the *Morning Jamboree* and the *Play Party Hour*. Green County's own "Uncle" Henry Warren and the Kentucky Mountaineers were often featured on WHAS shows. *Play Party Hour* was the most listened to radio event in the midwestern states.

WFPL enjoys a strong local following and invites Louisvillians to attend *Live Lunch* every day at 11:30 a.m. Crowds routinely form a line down Fourth Street as early as 11:00 a.m. The show even offers contributors a package lunch prior to the broadcast.

With over five hundred shows in the *Live Lunch* can, the program has become a staple of the Derby City music scene and a popular showcase for bands on their way up. Why, even your humble author is a *Live Lunch* alumnus. But that doesn't mean that big acts don't play too. Check the website (www.wfpk.com) before your next visit to Louisville. *Live Lunch* is located at 619 South Fourth Street.

MUSIC RANCH USA
WEST POINT, JEFFERSON COUNTY
SATURDAY NIGHT COUNTRY MUSIC SHOWS

This self-described jamboree is in West Point, a suburb of Louisville, located just southwest of the metropolitan area. Pass the candy-apple red caboose parked on the railroad tracks along Main, hook a right and you can't miss it. The Music Ranch is that big brown metal barn at the end of the quaint city street.

The Ranch is devoted to family entertainment and has a warm, inviting atmosphere. The auditorium welcomes country music acts as well as a variety of other styles of performance, provided that all standards of "quality, decency and respect" are met. So it probably won't be hosting Marilyn Manson anytime soon.

There is an adjoining restaurant for those wishing to make a night of it. Bands like the Kentucky Blue Belles and Kentucky Sassafras have been known to grace the stage. But the Sherman Tinnell Jamboree House Band functions as the regular host of these weekly shows.

The Ranch is the only structure in the area that's been built by "a jamboree family" specifically for a country music show. Completed in 1993, the theater has nearly five hundred padded seats, a snack bar and free parking in a well-lit, patrolled parking lot. Which is always a plus.

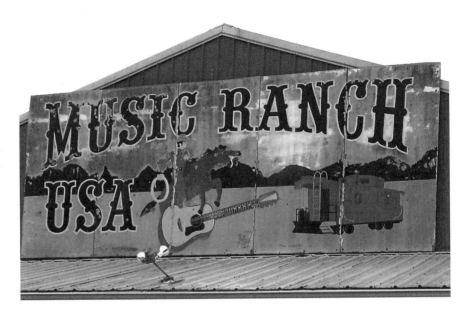

The Music Ranch sign, West Point. *Photo by the author.*

Music Ranch in West Point. *Photo by the author.*

The "ranch" around the place features rickety, Old West buildings that look transported from a Clint Eastwood flick. Be sure to grab some grub at the Star Restaurant next door and notice the famous faces on the wall. Folks from bluegrasser Karl Schiffert to rocker Robert Plant have dined here and posed for snapshots with the owners. The food has even made a few nationwide "Best Of" lists.

Contact Music Ranch USA at musicranchusa@insightbb.com or call (502) 543-6239. At this writing, the Music Ranch was experiencing a remodeling effort, so be sure to phone ahead.

OTHER LOUISVILLE-AREA EVENTS

Bashford Manor Baptist Church Jam, first Saturday of the month, 6:00–9:00 p.m. Contact Zack Purcell at (754) 281-5190. Located at 1908 Bashford Manor Lane.

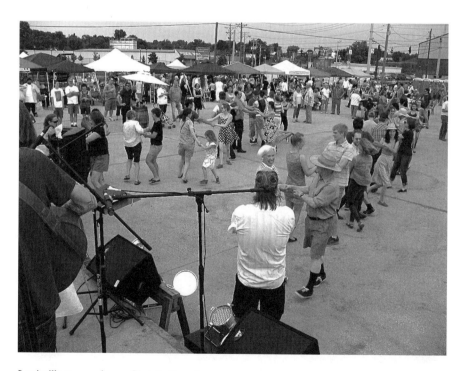

Louisville square dance. *Photo by the author.*

BBC Bluegrass Jam hosted by **Bluegrass Anonymous** every Wednesday night, 7:30 p.m. BBC St. Matthews, 3929 Shelbyville Road.
Hideaway Saloon bluegrass jam, Sunday nights, 8:00 p.m.–?
Matt Phelps Bluegrass Jam in the cabin at Boone Hollow, Kentucky, or at **Gerstle's** on Frankfort Avenue, every Tuesday, 8:00–11:00 p.m.
Silver Heights Bingo Hall, 6:00–10:00 p.m. on Tuesday nights. All levels play the Silver Heights Bingo Hall Jam, sometimes with three groups playing at the same time. The bluegrass jam at Silver Heights Bingo Hall is located at Blue Lick and South Park Roads, Louisville, Kentucky.

RABBIT HASH BARN DANCE
RABBIT HASH, BOONE COUNTY
FRIDAY NIGHT SHOWS (WINTER MONTHS)
SUNDAY NIGHT SHOWS (WARM WEATHER MONTHS)

When a scruffy old border collie named "Lucy Lou" is the duly elected mayor, you know you must be in hillbilly heaven.

Obviously, there's a certain laid-back attitude in the "town" of Rabbit Hash, a place named for the proliferation of bunnies escaping the floodwaters of the Ohio. The whole of the town includes only a few clapboard buildings sagging like the set of a Hollywood western. With your first step on the creaky planks of the old General Store, you are whisked back into the wistful days of yore. Inside, a dense glut of souvenirs, dry goods, feed bags and farm implements hangs from the ceiling, clutters the floor or cascades from wobbly antique tables. A vintage cash register rings from the desk behind me as I make my way to the back of the darkened walkway of pie safes, egg crates and barrels. Local homemade sorghum, honey and gift jars are stacked high while old-timers play checkers and swap whoppers around the pot-bellied stove in the corner. During my visit, I couldn't help myself. I bought a Rabbit Hash T-shirt, a hatpin and a "Mexican" Coke in a glass bottle. Up at the register, I cast my armful of goodies on the counter. The cashier rang me up and was kind enough to hip me to the musical goings-on in Rabbit Hash. I left with a smile on my face, a hastily scratched-out list of events and an "autographed" picture of Lucy Lou, the canine mayor.

Outside, you will find old tin signs rusting on weather-beaten walls while the river rolls lazily by. Buzzards roost on a barn by the bandstand as tourists (like me) snap pictures of the local color. What a perfect backdrop for a barn dance.

Rabbit Hash General Store. *Photo by the author.*

The dances are held on Friday nights during warmer months near the bandstand outside (inside the barn is where the beer and snacks are served). During winter months, shows occur indoors on Sunday afternoons. Jams occur around the old pot-bellied stove in the general store too. The bands to expect include the Tillers, the Rabbit Hash String Band and the Whiskey Bent Valley Boys from Pewee Valley, Kentucky. Three great groups, I might add, that have drawn inspiration from Rabbit Hash's own Tommy Taylor, the late great fiddler who spearheaded northern Kentucky's original old-time movement.

The town also hosts an Old-Timers Day on the Saturday before each Labor Day. Quilt and horse shows happen on a regular basis too.

I highly recommend a visit to Rabbit Hash, Kentucky. It has the best music *and* souvenirs. Take I-75 to Exit 181 West. Go through Burlington and continue past Dinsmore, following scenic KY 18 as it turns south along the Ohio River. Turn right onto Lower River Road at the General Store sign.

OLDE STAR MALL THEATRE
WILLIAMSTOWN, GRANT COUNTY
COUNTRY MUSIC FRIDAY NIGHTS
BLUEGRASS AND GOSPEL SATURDAY NIGHTS

Sometimes there is just inherent irony in the location of certain jamborees. The best example of this might be the Olde Star Mall. Jam coordinators Kati and Wayne have actually gone and repurposed an old Walmart into a barn dance. I must admit this is the kind of thing that does my ole heart good. To take a small business–crushing megaplex and then house a family-friendly bluegrass venue inside—well, that's so heart-warming it's almost perverse!

The Olde Star Mall Theatre is a wholesome entertainment facility that features the best in local and not-so-local talent in the world of country, bluegrass and gospel music. With its status as *the* home for country music dancing in Grant County, the theater is poised to remain a big part of northern Kentucky bluegrass history.

As usual, this place, like many others, is a smoke-free, alcohol-free, family environment. Local talent includes Kim Samuel's Kentucky Sassafras, plus regular back-up artists capable of everything from "sleek, straight-ahead bluegrass to more hard-country and folk-influenced songs."

The Olde Star Mall is located at 1418 North Main Street in Williamstown, Kentucky. Take Exit 156 (Barnes Road) off I-75 and go east to the light. Turn left. That's north Main Street (U.S. 25). The entrance to the mall is at the next traffic light, and the theater is located next to Tractor Supply. Stop in and do some dancing on the grave of a failed Walmart.

Call (859) 824-3200 for more information.

RICHWOOD OPRY
RICHWOOD FLEA MARKET
WALTON, BOONE COUNTY
OPEN JAM AT NOON ON SATURDAYS

Supplying great live country and bluegrass music to the greater Cincinnati area is the Richwood Opry. Formerly held at the Olde Star Theatre in Williamstown, Kentucky, the Opry has relocated just twenty minutes south

Richwood Flea Market. *Photo by the author.*

of Cincinnati, on the right of I-75. The Richwood Opry is also within a short drive of Rabbit Hash, Kentucky (see listing above). Why not make it a country music two-fer?

Since its inception, the show has featured top acts such as Doyle Lawson, Don Rigsby, IIIrd Tyme Out and Junior Sisk. The giant flea market is but a mere twenty miles south of Cincinnati and approximately fifty miles north of Lexington. Louisville is only an hour and some change away.

While at the Richwood Opry, try to take in a show by one of my favorites, the great Blair Carman. Carman is a terrific young pianist and Jerry Lee Lewis–style performer. Many a night I had the honor and pleasure of watching Blair develop his act at Layla's Bluegrass Inn in Nashville.

Shows take place in the Journey Building, located at 10915 Dixie Highway, Walton, Kentucky, 41094. Call (859) 474-0554 for more information.

OTHER EVENTS

Bardstown Opry at the Blue Grass Entertainment & Exposition Complex, 426 Sutherland Road, Bardstown, Kentucky, 40004. Be sure to call (859) 336-9839 for reservations and get there early because the parking lot fills up quick.

Friday and Saturday night country music shows and line dancing at **Bobby Mackey's**, the famously haunted boot-scoot in Wilder, Kentucky.

Open bluegrass jam at the **Hebron Masonic Lodge**, first Friday of the month, 6:00 p.m. Visit www.nkbma.com.

Open jam at **Molly Malone's** in Covington, Kentucky, from 8:00 p.m. to 11:00 p.m. on Mondays; Irish music on Tuesdays.

Open bluegrass jam at the **Newport Masonic Lodge**, second Friday of the month, 7:00 p.m. Visit www.nkbma.com.

Old Time Fiddlers Meeting at the Miamitown Firehouse, first Sunday of the month, 1:00 p.m.

Northern Kentucky Bluegrass Music Association hosts a jam session at **Willis Music** in Florence. More info can be found at www.nkbma.com.

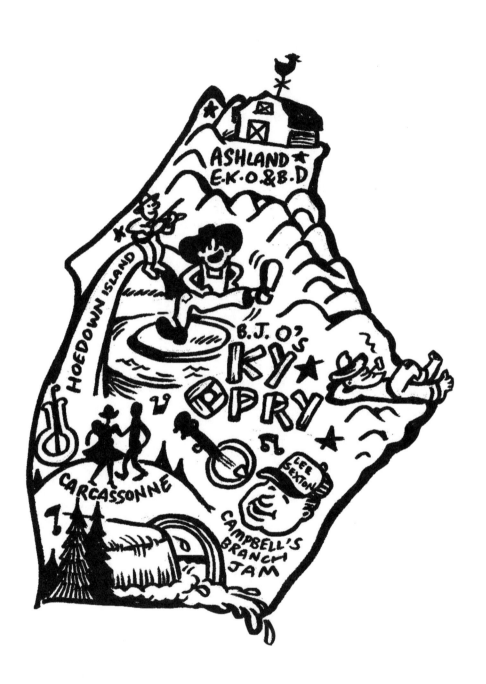

EASTERN KENTUCKY

LEE SEXTON FROM LINE FORK

I traveled hundreds of miles from my home in Paducah, Kentucky, to the extreme opposite end of the state. My purpose: to get in one good banjo lesson from the great Lee "Boy" Sexton, an eighty-two-year-old living legend. The famous Mr. Sexton sets up shop every Thursday night at the Campbell's Branch Jam, located in the schoolhouse between Ulvah and Line Fork, Kentucky.

We are talking deep Appalachia here, a kudzu-choked terrain that is disorienting to a flatlander like me, both in its dim, holler-borne lighting and eerie beauty. The twisting highways that wind through an endless mountain chain lead you past gravel roads and cemeteries posted with familiar names. Familiar, that is, to any maven of traditional mountain music. My head cranes left and right to read the rusted mailboxes of Holcombs, Sextons, Cornetts…all surnames of my favorite banjo pickers of the twentieth century.

Small towns that pepper the route of my journey appear stuck in time. The brick façades may show signs of age, but these buildings will have to do since such extreme topography limits the amount of urban sprawl. No doubt Walmarts would be here in greater number if the landscape were more, well, *horizontal.*

The sun seems to set around 4:00 p.m. in these parts, and my GPS is displaying a question mark. I'm disoriented and running out of enough sunlight to eyeball the rest of my way there. Vague directions relayed to

me over the phone last week (by Mr. Sexton himself!) are all I have to go by. Luckily, I recognize the old iron bridge he'd described, so I turn left to arrive an hour early. Campbell's Branch School is a '60s-era building that's been converted into a community center that proudly champions mountain culture, education and neighborliness.

On one side of the school, Lee's lessons are made available free of charge to anyone who shows up with a banjo in hand. Down the hall, refreshments and handshakes enliven a gathering of locals. Everyone is seated in folding chairs to hear weekly announcements, occasional politicking and a free concert of top-notch bluegrass music from the band Highway 6. This is the Campbell's Branch Jam, and it won't be long before a handful of folks start dancing to the strains of "Little Birdie" and "The Old Home Place." Suffice it to say, this is a show/jamboree for those of you more interested in the bluegrass edge of country. The picking is fast, the harmonies are tight and flatfoot clogging is the dancing style of choice.

Regardless of the emphasis on local music and fellowship, anyone from anywhere is encouraged to attend. In fact, I have never felt more welcomed, especially given the amount of anxiety that might precede one's stone cold entrance into such an obscure, far-flung place. They even took up a collection to help me pay for my gas.

Shame on Hollywood for painting deep Appalachia as a scary, unfriendly place, overrun with feuding hillbillies and Klansmen. All I've ever encountered were good folks and a musical tradition that captivates me as a Kentuckian. Yes, the only thing haunting here are the sounds of Lee Sexton's banjo ringing in the holler. It is a sound that has brought me over three hundred miles to learn from the master.

Back to my lesson with Lee. It becomes immediately obvious that the older Mr. Sexton has not lost his touch. Kicked back in his chair in an echo-laden classroom, wearing overalls and a beat-up camouflage cap, Lee "Boy" explains how a raccoon bite mangled his right thumb, preventing him from demonstrating his former "dropthumb" style. However, with his trademark "two-finger" picking style (which predates Earl Scruggs's meticulous bluegrass method), he runs quickly through such tunes as "Liza Jane," "Lost Indian," "Whiskey Before Breakfast," "Cumberland Gap," "Sweet Sunny South," "Last of Callahan," "Little Maggie," "Tennessee Breakdown" and his original "Line Fork Back Step." Before long, his four young students and I are starting to catch on a little, and the whole building starts to resonate in sync to Lee's old time "banjer."

Many of Sexton's songs have interesting back stories. According to old-time historian John Harrod, "Last of Callahan" is a tune that served as the

final request of a condemned fiddler named Callahan as he stood on the gallows deck. Or, as Harrod recounts:

> [Callahan] *says he has made up a tune while…in jail and would like to play it for them before mounting the gallows. His fiddle is brought to him and he sits on his coffin and plays the tune. When he has finished, he smashes the fiddle over his knee and declares that nobody will ever play that tune again and he climbs the steps to meet his maker. But there were some fiddlers present who remembered the tune and they are the ones who passed it down to us.*

According to Ray V. Prater, a *The Kentucky Explorer* contributor, Tollie Presley and Levi Hoover of Morgan County penned "Lost Indian." They tell the tale of a forbidden love between Falling Rocks, a Cherokee brave ridiculed by his tribe for a speech impediment, and the chief's daughter Little Faun. Chief Shining Moon forbid their marriage, fearful that their children would be born with the same handicap. This upset the two lovers so much that they leapt to their deaths from Table Rock. Shining Moon was so distraught over the double suicide that he wandered off into the mountains of eastern Kentucky, never to be heard from again.

It's an intriguing combination when tales like these are set to a "crooked" mountain banjo tuning. Sexton uses an old F-tuning in particular called "Sawmill," pitching his thumb string down between F and F#. As a result, there is a strange, dissonant quality that almost puts you in the mind of eastern music, as it even sounds like a *sitar* at times. In fact, with each song you really begin to understand how ancient the instrument truly is.

West African slaves introduced a gourd banjo variant, the akonting, to the Americas circa 1630–40. A low string was added much later by antebellum minstrel Joel Sweeney, who helped popularize the instrument through his minstrel show. According to author Layne Hendrickson in his article for *A Simple Life* magazine:

> *Upon their return home, Appalachian* [Civil War] *soldiers took the banjo to the most remote corners of the mountains where minstrels had yet to travel. Here the banjo found a home amongst the Scots-Irish dwelling in the secluded hollows and on the high ridges of the South. Perhaps the drone of the five-string banjo touched upon a deep cultural memory of the droning of their long lost bagpipes.*

It is quite possible that, centuries ago, variations of similar instruments migrated back and forth across the land masses of the Eastern Hemisphere, morphing along the way from one design to another. Lee's banjo tone and approach captures the timelessness of music itself.

Sexton is best known for his appearance in the hit film *Coal Miner's Daughter*. He also made a profound impression in the southern documentary *Searching for the Wrong-Eyed Jesus*, which appeared on BBC. Make no mistake though, Lee is no movie star. He has spent much of his life eking out a living in the coal mines of the Blue Diamond outfit. As a youngster during the Depression, he learned many of his songs firsthand from his uncle, the great Morgan Sexton, who mainly played in the old "two-finger" style. Variations of this picking pattern were as common in the mountains as the African-influenced "frailing" or clawhammer style.

In 1941, Lee began his long-running musical relationship with fiddler Marion Sumner (1920–1997) on Norton, Virginia's WNVA AM. In the 1950s, he was recorded by the Smithsonian Institute for the album *Mountain Music of Kentucky*—a must-have in my book. Sumner also played fiddle with my all-time favorite banjo man, Roscoe Holcomb, of Daisy, Kentucky.

I highly suggest that every reader pay a visit to Campbell's Branch, a special place of mountain hospitality, culture and music. You should do so sooner than later, as living legends like Mr. Sexton become more and more scarce with each passing year.

It is interesting how the relative isolation in all the nooks and crannies of eastern Kentucky gave rise to such a plethora of individuated styles, vocal inflections, dance steps and picking patterns. Cultural influx occurred as railroad, coal and timber industries acted as a conduit of movement in and out of the mountains. The essential influence of African American blues occurred during this era. But the mid-twentieth century would see radio, television, photographers and even well-meaning academics (those who determine "correctness," at least) slowly strip away cultural individuality like so much coal from the mountains.

CULTURAL STRIP MINING

"We call it 'cultural strip mining,'" says Kevin Howard, an associate of the Appalshop collective in Whitesburg, Kentucky. Howard oversees an open mic night on Wednesdays at the Letcher County nightclub Summit City. He also bemoans the demise of regional traditions and language.

"'Clawhammer banjo' is a term that was made up in the 1960s. But it was originally a style that was called anything from 'frailing' to 'overhand,' 'dropthumb' to 'club thumb banjo.'"

Whether it's the homogenizing effects of television signals bouncing through the hollers to find the cruciform aerials that await, or the well-meaning interloping of "Great Society" participants, time marches on with no regard for "the individual." Even the pilgrimages made down south by 1960s and '70s folk revivalists had an effect. Some would latch on to one particular style of playing and promote it over other styles among themselves. Such was the case when students discovered North Carolina's Tommy Jarrell and Fred Cockerham and began learning how to replicate their "Round Peak" playing style.

Banjoist Kyle Creed (1912–1982) of Surry County, North Carolina, said he had always thought his playing was unique until he became the subject of studious folkies. "Now I hear myself play everywhere I go!" he quipped.

Of course, anytime one places another human being under a microscope, for whatever altruistic reason, a change to that subject will be brought about. It's sad but true. Even I ran this risk while writing this book.

Before pop culture, before "folk studies" and the "War on Poverty," Appalachian traditions were handed down and distilled in the dusky recesses of long-forgotten places. Scots-Irish tunes and tales that date back to the eighteenth century mixed with African and Cherokee influences. They metamorphosed naturally over time within the solitude of the mountains. Later, the "clear channel" signals of late-night AM broadcasts would fire up the atmosphere—and incinerate American authenticity. WSM, the "Air Castle of the South," invaded the misty airspace with a Nashville sound that could tantalize one to abandon his own Kentucky way of playing. Prior to this advent, banjo and fiddle styles varied from holler to holler, home to home, grandpa to grandpa. For millennia, art and music had sprung organically from the imagination of millions of human minds. But not anymore.

Eastern Kentucky, as well as the rest of the state, still struggles to maintain its identity in the face of encroaching technologies. "Jack Tales," like those recorded in the terrific book *South from Hell-Fer-Sartin* or the *Foxfire* series, are mostly academically passed down now. For the most part, the same goes for Old English ballads and rhymes, mountain recipes, superstitions and sayings. These are now courses found on a folk camp's syllabus.

To make matters worse, post-modern apathy, irony, influence and affluence have taken their toll. Insulting caricatures depicted on reality television, Hollywood slam-jobs on the South and, quite simply, the movie *Deliverance*

have done irreparable damage to southern culture. These hurtful images are filmed and then electronically exported to the world, where opinions are formed about what America's Southland must be like. (And to think, our great-grandparents thought *radio* was going to be the biggest threat!)

Cultural co-op Appalshop and KET-KY (Kentucky's public television network) present a healthy, corrective take on Appalachia by employing the medium of film. And thanks to its dissemination via radio, television, movies and the Internet, bluegrass music is known worldwide and has a respectable mainstream following. Sure, it might be a formalized version of mountain music, but in this day and age, we're lucky to take what we can get.*

PIKE COUNTY JAMS

Regarding mountain music and media, WLSI, in Pikeville, was one of the first stations to broadcast live local "hillbilly music" in the 1950s and '60s. Fiddling royalty Charlie Stamper regularly played a thirty-minute set with his band on a show hosted by WLSI personality Al Hendershot, aka "Two Ton Baker, the Music Maker." For a mountain musician like Stamper, a radio gig was just another place to be heard when you weren't playing house parties, schools or fairs. (In this way, local programming on low-watt stations perhaps strengthened local playing styles. Plus, it helped keep the poor musician fed.)

According to old-time music expert and eastern Kentucky lawyer Larry Webster, Pike County's Reed family has overseen an unbroken fifty-year history of gatherings in their home on Big Creek near Sidney. Their picking party, the longest running of its kind in Kentucky, occurs every Saturday night and hosts a motley crew of both "invited and uninvited players."

The legendary Owen "Snake" Chapman oversaw a jam that took place in the kitchen of the historic home of Bert Hatfield (descendant of the old Hatfield feudists) in Hardy, Kentucky. He and most of his friends have passed away within the past ten years or more, so the jam is now defunct. But back in the day, Chapman would perform the Revolutionary War–era songs he learned from his elderly father, who had learned from *his* elderly father. In fact, all the Chapman men live into their hundreds, making it possible for the direct inter-generational transfer of colonial traditions. Some of the earliest-

*. "Mountain bluegrass," akin to the Stanley Brothers style, is a bluegrass sub-genre that preserves much of the old flavor of mountain music.

known music that can be learned in such a way has since been handed down to an entirely new generation, thanks to the late great "Snake" Chapman.

"When the banjo and the fiddle conjoined," says Webster, "it created a very unique sound on American soil. The Chapmans captured this, and it is historically unique." For ten years, Webster himself ran a jam that began in his home in Pikeville back in 1976. "Interesting people showed up. Some were even famous, come to find out. I just didn't know it at the time!"

Pikeville is equidistantly thirty miles from the borders of both Virginia and West Virginia. On any given Sunday drive, you can spot people out in the county gathering on their porches to pick as you go by. "It's like someone hired them as a tourist attraction," observes Webster.

Farther down the road is the Rusty Fork Restaurant in Elkhorn City. It showcases live mountain music, old-time and bluegrass for the tourists in town for the Breaks, "the Grand Canyon of the South."

A SECOND LOOK AT "PURITY"

There is an attempt by today's mountain music circles to keep their folkways "pure," with outside influences being shunned by academic culture-barons. KET's *Kentucky Music* program enforces an active ban on any music not created specifically in *eastern* Kentucky. Central, northern and western Kentucky old-time musicians are simply not allowed. Other Appalachian workshops uphold a similar notion of territorial purity as well. Agrarian poet and "Fugitive" cohort of Robert Penn Warren, Donald Davidson (1893–1968) argued for such distinctions of regional identity (although I'm not sure he would've drawn such a fine line).

Then again, such chauvinism is understandable, especially given how today's pop culture can even shame away a person's southern accent. However, inclusiveness was an authentic part of the old-time spirit of yore. Historian and fiddle expert John Harrod described the natural evolution of today's barn jam thusly: "[Over the years] banjos and fiddles made way for an electric guitar or two. Before you know it, there were drums and it went from old-time to include rock. Now it's customary for loud bands to make way for the banjos and fiddles again."

Waves of nostalgia occur in pop culture, whether it be the rockabilly revival of the 1980s, the swing revival in the '90s or the resurgence of old-time music due to *O Brother, Where Art Thou?* These large retro movements

are usually just fads that have little to do with either the original source material or contemporary mores. But they always serve to attract a small amount of new souls to older music, which is great! The object should be to encourage these recruits, not scold them for being outsiders. As former Old Crow Medicine Show fiddler Matt Kinman reminded me once, "It's just music, J.D. It's all just music."

The more philosophical reader might even postulate that there is actually no such thing as "authenticity." In a cause-and-effect universe, stimuli are just as natural as the effects they elicit. As a matter of course, technology advances as time marches on. Dehumanizing effects might occur as a byproduct of progress, but like it or not, this is just the way the world works. Furthermore, organizations, programs and trends that spring up to fight back and preserve traditions are just as "authentic" as the other "bad" things, making it a never-ending game of societal ping-pong. Despite it all, it's a debate probably best left to the Robert Penn Warrens and Donald Davidsons of the world.

MORE EASTERN KENTUCKY HIGHLIGHTS

The Cowan Creek School fights this "good fight" in its own way. The school is like a vacation camp for kids and adults who wish to connect to the safely held traditions of their mountain homeland.

John Harrod assists in the education at Cowan Creek. Harrod lives in Owen County, north of Frankfort, but was born and raised in Shelby County in the little town of Bagdad. He is well known for playing with and documenting many of the old-time musicians who learned their craft before the advent of radio. When he moved to Owen County in 1974, there were two local jams that included square dances. One was the Monterey Jamboree and the other was the Long Ridge Jamboree, held in an old schoolhouse. They had a band and a caller, happy dancers and lots of fellowship. Everything seemed very laid-back and community based, so much so that he just assumed this kind of thing was going on everywhere. But, of course, it wasn't, and sadly, the dancers and callers have all died out since.

"There is a jam at Appalshop on a Saturday night each month," Harrod offered. "There's also a dance in Morehead, Kentucky, but they take a break in the summer since they rely on the college." However, Harrod's favorite soiree is the Carcassonne Square Dance in Letcher County, which will be discussed in an entry below.

Lee Sexton and the author at the Campbell's Branch schoolhouse, Line Fork. *Photo by Jessica Wilkes.*

"It's like stepping back in time," Harrod said. "[It seems that] as the old-time music world evolves, square dances are evolving right along with it. And now you've got new guys like T Claw calling the dances. It's starting to get cool again."

The "Dare to Be Square" movement, where young people are getting into square dancing, is big now too. These organic, homespun events (what T Claw describes as "old-time socials") are in response to the sometimes-stodgy contra and Modern Western dances that have sprung up. "Some young people are putting on square dances because it's become hip again," Harrod laughed. "They say to hell with the contra dance."

There is a growing number of attendees of such old-time dance events, especially in Virginia and West Virginia—Clifftop in particular. And more and more people from Kentucky are making the trip across the border too.

The cycle of agrarian to urban to "agrarian by choice" is an interesting phenomenon, but it's just as natural as the original push to modernize. It's an ever-evolving world we live in, but thanks to Sexton, Webster, Harrod, Appalshop and the Cowan Creek School, the music will survive into the future, even if the myriad styles born in the hollers are ultimately lost to time.

> CARCASSONNE SQUARE DANCE
> CARCASSONNE, LETCHER COUNTY
> SECOND SATURDAYS

Four miles of gravel switchbacks must be traversed to reach the peak of the steep, misty mountain. Shifting into a lower gear and angling up a forty-five-degree incline, I almost feel like I'm on an amusement park ride, cutting left and right with each twist and turn. But it's all well worth it once you're finally to the top, basking in the welcoming, gaslight glow of the Carcassonne Community Center. Kentucky's longest-running continuous traditional square dance occurs here every second Saturday of the month from April to December. Built in 1931 as the Carcassonne High School, it now serves as a folk life center that encourages locals to learn square dancing, quilting and other crafts that would otherwise be gone with the wind.

If you're thinking of attending, bring your friends. The Community Center is perfect for large groups. Two-tone gray brick walls surround a large wooden dance floor and a short stage built for the caller and bands. An American flag hangs above the stage and is flanked by two heavy loudspeakers. They sit atop tripods and pipe out the hair-raising strains of Letcher County's greatest talents—folks like guitarist Sean Stamper, fiddler Ronald Smith, banjo legend Lee Sexton and his teenage heir-apparent, Jack Adams. Of course, other individuals and lineups have played throughout the dance's storied past. Marion Sumner (1920–1997), the "Fiddle King of the South," performed here when he wasn't on the road with Kitty Wells or in the studio. Pete Seeger's half brother Mike Seeger (1933–2009) filmed dancer Willis Fields here for the fantastic documentary *Talking Feet*. The "pie auction" scene in *Coal Miner's Daughter* was shot here too.

Kentucky music expert John Harrod has also graced these hallowed halls with fiddle in hand. "I played there a few times, but mostly I danced. It's all ages, families, kids, grandparents. It's like going back a hundred years."

Starting in 1954, the dance began being called by the great Charlie Whitaker, and he would call here for the next fifty years. Nearing retirement, Whitaker discovered seventeen-year-old Erin Conaugher, a dance student at the Cowan Creek Music School. Whitaker saw something in Erin, so he began handing down his knowledge to the new young apprentice. In fact, the two grew so close over the years that Erin began calling him "Grampa Charlie."

Sadly, Mr. Whitaker has since passed away, but Erin (now Conaugher-Stidham) carries on the tradition, overseeing dances not only at Carcassonne but at other events too, calling sets such as "The Texas Star" and "The Virginia Reel." If you come to Carcassonne, you will notice the roadside memorial sign that reads: "Dedicated to Charlie Whitaker, US Army Veteran, 38 Years in Education, 50 Years as a Square Dance Caller."

A fitting memorial for a true Appalachian folk hero. Dances start at 8:00 p.m. at the Community Center, Square Dance Road, Carcassonne, Kentucky, 41804. Three-dollar admission.

> ### Hoedown Island
> NATURAL BRIDGE STATE PARK, SLADE, POWELL COUNTY
> FRIDAY AND SATURDAY NIGHTS
> SUMMER MONTHS

Imagine the majesty of Kentucky's Natural Bridge, with its famous giant rock formation and bucolic splendor. The summer wind wafts the scent of pine needles, fresh grass, mountain air. And...what's that? The rhythm of tapping heels?

That's right. Every Saturday night, a long-running, old-fashioned square dance kicks off aboard the spacious outdoor patio on Hoedown Island. The little island can be seen just down the hill from the Hemlock Lodge. Paddle or walk on over, but don't forget your cloggin' shoes. Since the 1930s and '40s, people have held dances on these rocks while area musicians played. "Coon Creek Girl" Lily May Ledford (1917–1985) spoke of performing on the stone platform for tips during those years. Tourists arriving by passenger train from Lexington and Cincinnati would vacation at the Natural Bridge but stay for the entertainment. Of

course, the old steam trains no longer run that way, replaced in the '60s and '70s by Eisenhower's interstate system.

Hoedown Island was formalized as an official park attraction in 1962 with the help of the late square dance caller Richard Jett. Jett's behind-the-scenes work gave the tradition a permanent home at Natural Bridge State Park, where he would eventually call a whopping total of 1,319 dances over the next forty-four years. He, too, was a mountain dancer, with his favorites being "The Big Step," "The Virginia Reel" and "The Nine Pin Reel." As an expert on the subject, Jett authored the book *Square Dance Calling in the Mountains of Eastern Kentucky* (with Helen Price Stacy, 1971). He also hosted another jamboree in Campton, making him a very busy man. But tragically, Richard suffered a heart attack in 2006 and passed away while aboard the bandstand on Hoedown Island.

Jane Bolin, Jett's young understudy, was by his side that fateful night. According to Bolin, everybody thought Richard looked ill that evening. Even Jett himself decided to sit it out, calling for "the girl with the long, blonde hair," referring to Bolin.

"Jane will take it over if ever something were to go wrong," Jett had always thought. So he hollered for her to come over. Jane went and got Richard a chair to sit in until he felt better. She assumed calling the dances and spun his records while he just sat next to her looking pale and strange. Suddenly, he fell forward and received a gash on his forehead. And everything stopped.

"I didn't have CPR training," Bolin remembers with tears. "There I was out in all these trees. We didn't know what to do, so they called 911." That was the last square dance Richard Jett would ever oversee.

"I miss him dearly," Jane said. "His wife gave me all his equipment, and the following weekend I went right on through with it, and I've carried [the dance] on ever since. He would have wanted it that way."

"Everybody says he died doing what he loved," said park naturalist Tyler Morgan.

Jane has kept his phonograph records, his microphone and the stool he always sat on—all things special to her too. After all, she's been a regular at Hoedown Island for thirty-four years, clogging there since she was fifteen. Jane's dad dances here as well—*and* her two grown children. Now her daughter is pregnant with another future dancer, making that four generations of Hoedown Island dancers in the works. Life carries on.

If you find yourself visiting Hoedown Island one day, take a look at the shrine to Jett on the back wall of the little bandstand. It features a poem framed next to his memorial placard. It is actually the lyrics to "The Legend

of the Island," a song written by Darrel Rogers in honor of the late Jett. It goes like this:

There's a place up in the mountains
Where the folks all gather round
Just to hear the Bluegrass Music
Croon that Appalachian sound.
It was there that I first met him
It was there my life did change
When the legend of the Island
Got me on the Opry stage!

He's the King of Hoedown Island
A legend known by all
Who came to see his magic
As he begins to call
It's allemande left your corner
Swing your partner round and round
He's the legend of the Island
A King without a crown.

Well the Appalachian way of life
It's simple and so sweet
And when the city folks come dancing
They just have to tap their feet
He's a Teacher of the Hoedown
He's a friend to one and all
He's the Legend of the Island
When he begins to call.

Well the years have come and gone by
And some things in life have changed
But the Appalachian Music
Still remains the same
So if you ever go there
To hear the Legend call.
I promise you a good time
Will be had by one and all!

SALTY DOG RAG (Hoedown Island Style)

RECORD: SALTY DOG RAG (Decca # 27981)

STARTING POSITION: Couple facing counter-clockwise holding inside hands

-----Wait 16 counts

A. RIGHT, LEFT, RIGHT, HOP (4 counts)
 Count # 1 - One step on right foot diagonally to right.
 Count # 2 - Place left foot behind right foot.
 Count # 3 - Take one step on right foot.
 Count # 4 - Swing left foot over right foot and hop on
 right foot.

LEFT, RIGHT, LEFT, HOP (4 counts)
 Count # 1 - Take one step on left foot diagonally to left.
 Count # 2 - Place right foot behind left.
 Count # 3 - Take one step on left foot.
 Count # 4 - Swing right foot over left foot and hop on
 left foot.

B. RIGHT HOP, LEFT HOP, RIGHT HOP, LEFT HOP (4 hop steps,
 starting with right foot, 4 counts).

C. REPEAT A.

D. REPEAT B.

E. 16 HOP STEPS (16 counts)
 Make a figure-eight pattern with the boy moving behind
 his pardner and to the right. Girl start this movement by
 moving in front of her pardner and to the left as the
 diagram below illustrates:

STARTING POSITION OF PART "E"

G - Gentleman
L - Lady

58

Dance instructions by the late Richard Jett, Powell County. *Jane Bolin collection.*

Unlike some surviving square dances in Kentucky, recorded music is preferred to live bands at Hoedown Island. It's what Richard Jett always opted for.

"This is a family place. No drinking is allowed," Bolin explained. "That's one of the reasons we don't have bands. We've had them in the past, but we've had to call them down a time or two." However, before Jett's death,

he had organized a singing group of young vocalists, the Troubadours, to perform between the dances. This is a tradition that Bolin proudly continues to this day. So come on down and hear the live music too.

If you don't know how to clog or square dance, don't worry. Bolin and the folks on Hoedown Island promise "you don't even have to know how to dance to have a barrel of fun." Those wishing to learn can watch the experts and, as Ranger Morgan puts it, "get a feel for the moves." What better "date night" is there than a trip across the rippling waters with your loved one, soon to enjoy the music of the mountains under a starry night? Richard Jett must be looking down with pride.

Cost for the square dances is only three dollars per person, and kids twelve and under get in free. Clogging and line dancing happen for the first hour, then the Troubadours sing a gospel tune. Visiting groups often give clogging demonstrations. And the dress code is always "camp casual."

2135 Natural Bridge Road, Slade, Kentucky, 40376 is the address, and the phone number is (606) 663-2214.

DOCK PICKIN' AT LAKE CUMBERLAND
BEAVER CREEK MARINA
SOMERSET, PULASKI COUNTY
EVERY WEEKEND, WEATHER PERMITTING

The Lake Cumberland area is known for its Master Musicians Festival, but if you ask the local lake-lubbers, they'll tell you the *real* master musicians can be found at the old marina, two miles down from Beaver Creek Resort. Every year, Travis Harris assembles his "horde of pickers" at the dock to sit around his "ole pontoon on the pier" and jam into the wee hours of the night.

Harris has granted me permission to spread the word about his jam, since he ordinarily relies on word of mouth only. The jams occur every weekend, when weather permits, and typically have a great turnout. Marina customers migrate from up and down the surrounding piers to hear the music. Many of the folks are from out of state. According to Harris, some seem to be mesmerized by the sound of bluegrass music, especially those from Indiana and Ohio, who claim not to have heard such sounds since they were children. Everyone always has a blast and ends up meeting new folks and catching up with old friends, too.

Travis Harris and friends "dock pickin'" on Lake Cumberland. *Photo by Chelsea Decker.*

As Travis puts it: "Who doesn't like to see beautiful scenery and hear traditional music?"

Who indeed, Travis…who indeed. Visit lakecumberland.com for more information on the area.

> ## LAKE CUMBERLAND JAMMERS
> ### THE CARNEGIE COMMUNITY ARTS CENTER
> ### SOMERSET, PULASKI COUNTY
> ### EVERY TUESDAY, 6:00–8:30 P.M.

The Lake Cumberland Jammers meet year round every Tuesday night. Musicians and spectators (the "pickers" and the "grinners," respectively) begin filing into the Carnegie Community Arts Center at approximately 5:30, and by 6:00 p.m., the music is in full swing. All attendees are treated to an evening of down-home hillbilly music with refreshments provided with no charge.

The "jammers" sit in a large circle of chairs and take turns singing their favorite songs. And unlike some jams, this circle grows larger to accommodate new talent. The tunes include old-time favorites like "Wildwood Flower," bluegrass standards like "The Old Homeplace," country classics like "Folsom Prison Blues" and gospel songs like "The Old Crossroads." You might even get to hear an original tune or two, penned by some of the locals. Audience members occasionally step into the circle to sing or pick one of their favorites too…grinning all the while, no doubt. 107 North Main Street, Somerset, Kentucky.

> ## CUMBERLAND FALLS JAM
> ### CORBIN, KNOX COUNTY
> ### SELECT MONDAYS

Cumberland Falls, with its 125-foot-wide curtain of falling waters, is known as the "Niagara of the South." It is also the only place in the western hemisphere where you can see the phenomenon of a "moonbow," the nocturnal equivalent of a rainbow—a ghostly aura that bends beneath each full moon on a cloudless night sky. What could make this place any more special? How about some mountain music to go with it?

Twice a month on Mondays, the Cumberland Falls State Park hosts its Jam Session series. All musicians, plus any guests of the park, are invited to assume the stage during the open-mic format. The style of music is primarily "older bluegrass" standards, but some old-time and country tunes can be expected too. Non-musicians are encouraged to just sit back, relax and enjoy the tunes heard throughout the Dupont Lodge. Come break time, why not step outside and take in a few moonbows? After all, what better way is there to view the "Blue Moon of Kentucky"?

According to the website: "Jam sessions start at 6:30 p.m. in the lodge and run until 9:30 p.m. Come early for the country buffet at the Riverview Restaurant, also in the Dupont Lodge." The schedule can be seen in the events section of my favorite magazine, *The Kentucky Explorer* (to which I highly suggest a subscription), or by calling (606) 528-4121 or (800) 325-0063.

Cumberland Falls State Park is at 7351 Highway 90, Corbin, Kentucky, 40701.

HINDMAN JAMS
HINDMAN, KNOTT COUNTY

Step on in and sign the ledger at the door to the Knott County Human Services Center. Admission to its "Pickin' and Grinnin'" event is free, but donations are always welcome. Now that you've ponied up, you can take a seat. Soon you'll be swaying to the rhythm of the Hindman bluegrass jam, featuring lots of great talent from the Knott County area. Perhaps you'll also get to see a performance by contemporary bluegrass groups Mt. Melody or Kentucky Mountain Grass. But if you're lucky, you might hear the influence of the late great local fiddler Hiram Stamper (1893–1992), a legend in these parts.

The nearby Hindman Settlement School conducts its "Family Folk Week" every year in June with an emphasis on old-time music, dance and crafts. The institution and its events have earned praise as "the best in the mountains."

Founded in 1902 by progressive educators May Stone and Katherine Pettit, the school has transformed the community of Hindman and greatly contributed to the progress of the entire region. "I guess they thought we were all a bunch of heathens!" joked eighty-one-year-old alumnus Charlie Stamper, son of Hiram.

Seriously though, the place promotes and preserves the music, culture and literary achievements of southeastern Kentucky and has always been there for the community, surviving and adapting to the modern needs of the people of the mountains. It supplements the programs of the local education system, hosts workshops and provides space for an ambitious new arts and crafts cooperative.

This kind of community support has been going on in Hindman for decades. Along with many other contributions, the works of renowned musicologists Loraine Wyman, John Jacob Niles and Mary Wheeler were transcribed at the Hindman Settlement School. Niles made four extended trips into the southern Appalachians as an assistant to photographer Doris Ulmann, recording traditional songs from oral sources. Wheeler traveled from Paducah to teach at the school and study the songs of eastern Kentucky. Their works, which attracted the attention of famous folklorists Cecil Sharp and Alan Lomax, are today archived at Berea College. Visit Berea.org and remember to appreciate the work of all those involved at both the Hindman and Berea schools.

And don't forget, Pickin' and Grinnin' takes place every Tuesday from 6:00 to 9:00 p.m. at 40 Center Street, Hindman, Kentucky, 41822, near downtown. Bring along an instrument and sit in too. The more the merrier.

HYDEN BLUEGRASS JAM
HYDEN, LESLIE COUNTY
EVERY THURSDAY NIGHT, 6:00–9:00 P.M.-ISH

Keep your eyes peeled for the store with the large glass window. It's just around the corner from the bank and near the hardware store on Main Street in Hyden, Kentucky. Then follow the strains of the Hyden Kentucky Bluegrass Jam and you're there.

It's not as if they're trying to keep the jam a secret. It's just that the place ain't all that fancy. They themselves admit that there is zero ambiance and not much to see—and only a few neon poster-board signs to mark the location. I beg to differ. I thought the place had a definite vibe. Sure, the jittery strobe of the fluorescent lighting was a tad harsh. And yes, the folding chairs were a bit bent. And come to think of it, there were some dusty stacks of lumber and random refuse piled by the door, too. But the bright red barn backdrop, the sound of impeccable Hyden talent and the smell of hamburgers were

enough to lure me in from clear across the street. Indeed, with two bucks you, too, will be in like Flynn where a nice sizable dance floor awaits your dancing shoes.

Hyden Square Dance
Leslie County Center

Over on Maple Street, square dances are held at the HCTC Leslie County Center Gymnasium. Unlike the gritty digs of the Bluegrass Jam, the Hyden Square Dance provides an immaculate setting and a clear destination for your GPS: 108 Maple, Hyden, Kentucky.

Concessions are available for the three-dollar door charge (free for the kiddos, K–12!). With deals like this and the two-dollar jam, you'll be sure to stop in Hyden as you go waltzing across Kentucky.

Kentucky School of Bluegrass and Traditional Music, Hyden. *Photo by the author.*

> ### MEADOWGREEN PARK MUSIC HALL
> #### CLAY CITY, POWELL COUNTY
> #### SATURDAY NIGHTS, 7:00 P.M., OCTOBER–MAY

Off KY 82 near Clay City, the Meadowgreen Park Music Hall stands, erected for the sole purpose of preserving bluegrass music. But back in 1977, before its construction, the Kentucky Friends of Bluegrass, along with aptly named park owner Forest Meadows, held their first bluegrass festival on a humble open-air stage. Beautifully situated just outside the Daniel Boone National Forest, the park still maintains this original outdoor amphitheater some ten miles from the Red River Gorge.

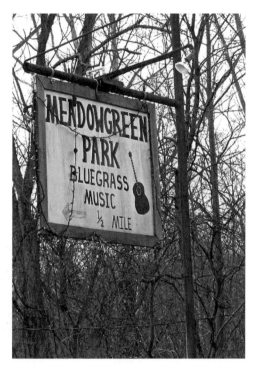

Meadowgreen Park is one of the most historic and naturally preserved areas in Kentucky. The area around Red River Gorge is fabled for its unspoiled beauty and natural rock-climbing areas. In 1986, the

Meadowgreen Park sign, Clay City. *Photo by the author.*

one-hundred-acre Meadowgreen Park added a large barn structure to host events in case of rain. Otherwise, the rustic outdoor freestanding stage (that kind you've seen in many a bluegrass retrospective, with a lumber back-wall and classic hand-lettered signage) hosts bands. With such a wide-open, glorious spread, the Meadowgreen Park has steadily grown to become the "Main Bluegrass Music Venue in Kentucky."

Well-known acts such as Bill Monroe, Ralph Stanley, IIIrd Tyme Out, J.D. Crowe and the New South and more have graced the stage over the years. Many local bluegrass bands lucky enough to qualify have played there too.

Those interested in seeing a show should call (606) 663-9008. Then program this address into your GPS: 465 Forge Mill, Clay City, Kentucky, 40312.

UPTOWN OPRY
WHITLEY CITY, MCCREARY COUNTY
FRIDAYS, 7:00 P.M.

Enjoy live country, rockabilly and western swing music with Hap Strunk & Southern Smoke every Friday at 7:00 p.m. at the Uptown Opry House. Hear hot picking and singing from the Southern Angels: Lindsey, Vanessa and DeAnna King. Their music is perfect for fans of such acts as Hank Williams, Porter Wagoner, Wilburn Brothers, Ray Price, Hank Snow, George Jones, Merle Haggard and Dolly Parton. Those are some big cowboy boots to fill, but something tells me Hap and company are up to the challenge.

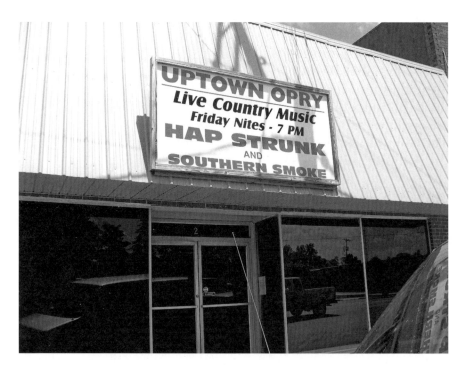

Uptown Opry, Whitley City. *Photo by the author.*

It all goes down under the rustic lattice rafters, patriotic bunting and oversized treble clef. Microphone stands are sleeved with vertical *Grand Ole Opry*–style sign panels for that authentic feeling. And for those unable to attend, the *Uptown Opry* is cablecast to McCreary, Scott, Whitley and Campbell Counties aboard MBR-TV. It is also broadcast over WHAY radio in Whitley City and HAY98.com on Tuesdays at 7:00 p.m. and Sundays at 1:00 p.m. It always does my heart good to see these local events broadcast on the radio, just like they were in the glory years of the twentieth century.

Come take in a show while Chef Doug prepares his special "island catfish" and red beans and rice every Friday night too. Sounds good to me! It is located at 25 Main Street in downtown Whitley City, Kentucky.

INTERVIEW WITH JOHN BACK, EASTERN KENTUCKY MUSICIAN

> LETCHER COUNTY

I called up Mr. John Back, an acquaintance of mine in Letcher County and an expert on the music scene there. We had met at the Campbell's Branch schoolhouse jam a few years back. I thought I'd get an update on the goings-on of this very special part of our country. Here's what was said.

Is your group still performing at the Campbell's Branch jam?
Yes. Me and my cousin and my wife work together with a new group. We play flat-top guitars in a band called Bak2Bak. We play every once in a while at Summit City in Whitesburg, a local music place that serves alcohol. [We] play down there from time to time. We'll have a song up on Facebook soon.

What are some old tunes unique to eastern Kentucky?
Well, let's see. There's a bunch of them. "Shady Grove," "Little Maggie," "Hook and Line." That's one they like to square dance to.

Is there much of a square dance or clogging scene out there?
Yeah, it's still going on. Folks dance at Campbell's Branch every Friday night. There's also another jam over in Hemphill, near Jenkins and Neon, on Saturday nights.

They have a square dance out in Carcassonne, in a school where my uncle went. It used to be a boarding school on top of a mountain. They have it once a month on a weekend.

Who are some pickers keeping alive the old traditions?
Jack Adams is still pickin', playing a lot of banjo, guitar, bass…he's really special. He's about fourteen or fifteen years old. Will Caudill is one of those singer-songwriters and a typical old mountain-style singer. He's good at it, and it seems to be going well.

What about the old fiddle styles?
Actually in this eastern area, Ralph Stanley's fella Kenny Baker was pretty famous. And I'm proud to say I had the privilege of knowing and playing with Marion Sumner. Marion played with Kitty Wells and Cowboy Copas. He had a musician's card in the Nashville union. [Marion has also since passed away.]

And what about the "two-finger" style of banjo that Lee Sexton plays? It's been almost a year since I've been out there. Is Lee still active?
He's doing fine as far as I know. He and his wife go to Senior Citizens every day. He's still pickin'.

Basically, I'm not an authority on his banjo style, but Lee's uncle Morgan [Sexton] played an old, *old* style of banjo, although Lee sort of updated it a little. Where it came from I don't know. But Morgan was Lee's original influence. Appalshop has a record by him, if you ever get a chance to pick it up. Then there's Freddy's dad, Frank Campbell. Everybody calls him "Nub."*

What is the future of traditional music in Kentucky?
It's very much alive and well in this part of the country. Lots of people come to Campbell's Branch, and they have a festival in Blackey, Kentucky…that's 41804 [zip code]. It's called Blackey Day. Everybody that lives here goes there and has a great time.

What is special about eastern Kentucky music?
Its uniqueness. There is a lot of raw talent there. Good-quality pickers with excellent timing, which is important. But they have fun. They'll make the

*. Mr. Campbell also plays in a two-finger style.

words different in some of the old songs, where people have added lines over the years. It's just fun and unique. And most of the people who play, well, you can't get them to play anything else. It may be considered old-fashioned or primitive, but the quality is there. But that's the ones who are good at it.

BILLIE JEAN OSBOURNE'S KENTUCKY OPRY
MOUNTAIN ARTS CENTER
PRESTONSBURG, FLOYD COUNTY
WEEKLY SHOWS

Held in Prestonsburg's Mountain Arts Center, a state-of-the-art complex, Billie Jean Osbourne's Kentucky Opry is a variety show you'll surely want to see. Acting almost as the eastern bookend to Clay Campbell's Kentucky Opry in the Jackson Purchase, this 1,054-seat opry house serves a similar function: to keep people entertained by hosting top acts and launching new talent. It also features a recording studio, an education room and an art gallery.

Comedy and country music go hand in hand here, with acts like the propeller beanie–bedecked country bumpkin Munroe and the wunderkinds known as the Kentucky Opry Junior Pros. Created as a sort of training ground for the opry, the Junior Pros are a versatile assembly of young musicians and singers. They range in age from elementary school to college and represent the finest young talent in all of eastern Kentucky. As they say at the MAC center, "If you want to discover today the stars of tomorrow, look no further than Billie Jean's Kentucky Opry Pros."

For the main act, southern gospel, bluegrass, country and patriotic tunes are the strains to expect. All these styles are performed by folks skilled to do justice to their famous forbearers. I am referring to the namesakes of the nearby "Country Music Highway": Loretta Lynn, Dwight Yoakam, Merle Haggard and the list goes on and on. Each of these household names reminds us that Prestonsburg and Billie Jean Osbourne's Kentucky Opry are smack dab in a hillbilly music hotbed.

Yes, these are tough acts to follow, but Billie Jean and company are happily up to the task. For her efforts in unearthing new talent, Ms. Osbourne has received a Governor's Award in the Arts and a Community Arts Award from the Kentucky Arts Council. Come see the next famous name to be added to a highway sign, and you'll be able to say, "I knew 'em when..."

For more information about Billie Jean Osborne's Kentucky Opry or to order tickets, call (888) MAC-ARTS (622-2787).

OTHER EVENTS

Appalshop Old-Time Jam, first Saturdays at 1:00 p.m. from October to May, 91 Madison Avenue, Whitesburg, Kentucky. For information, call (606) 633-0108.

The Eastern Kentucky Opry & Jamboree Barn, 3238 State Route 5, Ashland, Kentucky, but when last I checked, the opry was experiencing a pause in activities.

Music in the Park, first Friday nights, June–August, Daniel Boone National Forest (between Cave Run Lake and Red River Gorge), Menifee County.

Somerset Square Dances, St. Mildred's O'Bryan Center, 203 South Central Avenue, 7:30–10:30 p.m., lessons at 7:00 p.m.

Virginia-Kentucky Opry, 724 Park Avenue, Norton, Virginia, 24273. Paintsville hosts its **Front Porch Pickin'** at the Country Music Highway Museum. Hot bluegrass talent and dancing go down every Thursday night.

AFTERWORD

I'd like to thank the reader for taking time to acquaint him or herself with the subject of my passion. I'd also like to remind every fan of traditional Kentucky music that time is of the essence. If we wish to sneak in one last glimpse of the generation whose musical sensibilities were formed during the Depression era, we must hurry. I count myself lucky to have lived in a time that overlapped the lives of Lee Sexton, John Lanham, Scottie Henson, Stanley Walker and Charlie Stamper, among the many others I've been fortunate enough to meet.

To illustrate how quickly opportunities slip away, I have compiled a short list of defunct jamborees, barn dances and radio oprys, both notable and obscure. Don't let the existing events I've listed go unattended and fade away into obscurity too.

Just remember, the information in this book is subject to change. The very nature of a "pickin' party" requires the willingness of its participants to show up. Locations change, and people give up, quit or, well, die. Please phone ahead or check online before planning a trip.

Now go have fun!

RIP Defunct Kentucky Jamborees

Carlisle Family Barn Dance
(WLAP, Louisville)

Charlie "Chubby" King Jam
Paducah

Dycusburg Jam
Dycusburg Grocery

Hilltop Jamboree
(WGRC, Louisville)

Hilltop Studios
Hardin

Jim's Music Store Jam
Cadiz

Jim's Opry
Nortonville

Kentucky Mountain Barn Dance
(WKLX, Brownsville)

Liberty Theatre Barn Dance
(WCKY, Covington)

Lions Club Square Dance
Broadway, Paducah

Long Ridge Kentucky Jamboree
Long Ridge

MHS Booster Club Dance
Mayfield

Monterey Jamboree
Monterey

Morning Jamboree
(WHAS, Louisville)

Owen "Snake" Chapman Jam
Hardy

Play Party Hour
(WHAS, Louisville)

Symsonia Old Time Auction Barn
Said Road, Symsonia

WCKY Jamboree
(WCKY, Covington)

Yellow Rose Jam
Oaks Road, Paducah

SQUARE DANCE CLUBS

BACHELORS & BACHELORETTES
Lexington
Contact: Henry Sowers (505) 863-4344

BELLES N BEAUS
Louisville
Contact: Felix Swiderski fswiderski@bellsouth.net

BLUEGRASS SQUARES
Louisville
Contact: Tillie Sapp (502) 239-9133

CARCASSONNE SQUARE DANCE
Longest-running traditional square dance in Kentucky
Carcassonne

CHARLIE'S ANGELS
Louisville
Contact: Charlie Wheatley (502) 239-1956

CONSTITUTION SQUARES
Lexington

DAYTIME SQUARES AND ROUNDS
Louisville

DO SI DOS
Lexington
Contact: Terry Bay (859) 268-5264

DOWN UNDER SQUARES
Nicholasville

DUDES & DOLLS
Danville
Contact: Tom Miracle (606) 626-0697

GHOST DANCERS
Louisville
Contact: Mary Lou Schmidt (502) 961-7035

GRAND SQUARES
Radcliffe

HARDIN CO. FAIR SQUARES
Jamestown
Contact: Charlotte Allen (270) 735-6802

HORSESHOE SQUARES
Elizabethtown
Contact: Tom Kopman (812) 969-3537

KENTUCKIANA SQUARES
Louisville
Contact: Mary Waldridge (502) 380-6192

KENTUCKY GRAND SQUARES
Winchester

LAKE CUMBERLAND SQUARES
Somerset

Square Dance Clubs

Rhythm Rounds
Lexington
Contact: Terry Chism (502) 695-4026

Russell County Ramblers
Russell Springs

Shepherdsville Stompers
Shepherdsville

Sundowners
Lexington
Contact: Ken McIntyre (502) 797-3304

Wheeler Dealers
Louisville
Contact: Wanda Wagner (859) 272-4769

SQUARE DANCE LESSONS

FORT LOGAN PIONEERS
Stanford
Contact: Jerry Bailey (606) 669-7327

GRAND SQUARES
Radcliff
Contact: Steve Hockman (270) 668-4178

LAKE CUMBERLAND SQUARES
Somerset
Contact: Jill Blair (606) 219-1539

KENTUCKY GRAND SQUARES
Winchester
Contact: Dan Graham (859) 745-2871

SHEPHERDSVILLE STOMPERS
Shepherdsville
Contact: Vickie Emberson (502) 432-9463

SOMER-SETS
Somerset
Contact: Elmer Garland (606) 423-3150

BLUEGRASS AND TRADITIONAL MUSIC FESTIVALS

BARDSTOWN BLUEGRASS FESTIVAL
June
Bardstown

BILL MONROE
September
Owensboro

BLUEGRASS IN THE PARK FESTIVAL
August
Henderson

BLUEGRASS 101 BLUEGRASS FESTIVAL
August
Shepherdsville

BLUEGRASS THROUGH THE YEARS
September
Prestonsburg

CARTER COUNTY SHRINERS FESTIVAL
July
Olive Hill

CROWE FEST
September
Wilmore

CUMBERLAND RIVER BLUEGRASS FESTIVAL
September
Burkesville

FESTIVAL OF THE BLUEGRASS
June
Lexington

FRANKLIN MUSIC FESTIVAL
September
Franklin

GOIN' BACK TO HARLAN FESTIVAL
June
Harlan

HILLBILLY DAYS
April
Pikeville

BLUEGRASS AND TRADITIONAL MUSIC FESTIVALS

JERUSALEM RIDGE
October
Rosine

RUDY FEST BLUEGRASS FESTIVAL
June
Grayson

LAKE CUMBERLAND BLUEGRASS FESTIVAL
August
Russell Springs

SALLY GAP BLUEGRASS FESTIVAL
May
Williamsburg

LAWSONS FALL BLUEGRASS FESTIVAL
September
Eastern

SALT LICK BLUEGRASS FESTIVAL
February
Shepherdsville

LAWSONS SPRING BLUEGRASS FESTIVAL
May
Eastern

SEEDTIME ON THE CUMBERLAND
June
Whitesburg

MEADOWGREEN PARK FALL FESTIVAL
September
Clay City

VINE GROVE BLUEGRASS FESTIVAL
September
Vine Grove

NATIONAL JUG BAND JUBILEE
September
Louisville

NEWGRASS FESTIVAL
October
Bowling Green

POPPY MOUNTAIN BLUEGRASS FESTIVAL
September
Morehead

RENFRO VALLEY
June
Renfro Valley

ROMPFEST
June
Owensboro

BIBLIOGRAPHY

BOOKS

Cunningham, Bill. *On Bended Knees*. Kuttawa, KY: McClanahan Publishing, 1983.

Fletcher, Tom. *100 Years of the Negro in Show Business!* Cambridge, MA: Da Capo Press, Inc., 1984.

LeBlanc, Thomas J. "The Medicine Show." *The American Mercury* 5, no. 18 (June 1925): 232.

Rhodes, Allan, and E.L. Robertson. *Paducahans, Famous and Not So Famous*. Paducah, KY, booklet, n.d.

Rooney, James. *Bossmen: Bill Monroe & Muddy Waters*. New York: Dial Press, 1971.

Stamper, Pete. *It All Happened in Renfro Valley*. Lexington: University of Kentucky Press, 1999.

Valley, F. *The Companion to Traditional Irish Music*. New York: New York University Press, 1999.

West, Gary P. *101 Must Places to Visit in Kentucky Before You Die*. Morley, MO: Acclaim Press, 2009.

Wheeler, Mary. *Roustabout Songs*. New York: Remick Music Corporation, 1939.

———. *Steamboatin' Days*. Baton Rouge: Louisiana State University Press, 1944.

Wolfe, Charles K. *A Good-Natured Riot: The Birth of the Grand Ole Opry*. Nashville: TN: Country Music Foundation Press, 1999.

———. *Kentucky Country*. Lexington: University Press of Kentucky, 1996.

Wyatt, Marshall. *Good for What Ails You: Music of the Medicine Shows.* Raleigh, NC: Old Hat Records liner notes, 2004.

PUBLICATIONS

Fothergill, Joe. "Berea Musicians." *Kentucky Explorer* (a series across various issues) 27, nos. 8–13 (January–June 2013).
Hendrickson, Kelly Layne. "Banjo." *A Simple Life* 3, no. 4 (Fall 2012): 50–55.
Matteson, Richard L. "The Stamper Family: Kentucky Fiddlers." *Fiddler Magazine* 18, no. 4 (Winter 2011–12): 12–20.
Perkins, Ray, Laura Johnson and Carolyn M. Scott. "Uncle Henry and the Original Kentucky Mountaineers." *Kentucky Explorer* 27, no. 5 (October 2012): 19–22.
Prater, Ray V. "Saga of the Lost Indian." *Kentucky Explorer* 24, no. 2 (June 2009): 42.
Settles, Dr. David B. "Berea Homecoming Festival Was a Major Attraction for 15 Years." *Kentucky Explorer* 21, no. 10 (April 2008): 33–36.

WEBSITES

America's Happiest Music: Jugband Jubilee. "History." www.jugbandjubilee.org/history.htm.
Belle of Louisville (2013). "The Belle of Louisville Timeline." belleoflouisville.org.
Lincoln Jamboree (2003). "Joel Ray Sprowls." www.lincolnjamboree.com.
Morehead State University: Kentucky Center for Traditional Music (2012). "About KCTM." www.moreheadstate.edu.
Mountain Arts Center (2013). www.macarts.com.
Woodsongs Old-Time Radio Hour (2013). www.woodsongs.com.

INTERVIEWS

Allen, Bennie. Personal communication, July 27, 2013.
Back, John. Personal communication, February 17, 2013.
Bolin, Jane. Personal communication, June 3, 2013.
Brinkman, Karen. Personal communication, March 25, 2013.
Butler, Earl. Personal communication, May 14, 2011.

Chambers, Kelly. "RE: Introductions" e-mail to author, June 10, 2013.
Childers, Russ. "RUSS-Edit and send to Mike Oberst" e-mail to author, May 22, 2013.
Coffey, Don. Personal communication, March 24, 2013.
Doolin, Elvis. Personal communication, July 6, 2013.
Fiser, Van D. Personal communication, December 25, 2008.
Fothergill, Joe. "RE: Renfro Valley" e-mail to author, July 5, 2013.
Gage, John. Personal communication, February 16, 2013.
Harris, Travis. "Dock Pickin' Photos" e-mail to author, June 13, 2013.
Harrod, John. Personal communication, July 5, 2013.
Hensley, Jon. "RE: Barn Dance" e-mail to author, March 13, 2013.
Henson, Scottie. Personal communication, July 17, 2013.
Howard, Kevin. Personal communication, March 24, 2013.
Lamb, Donna. Personal communication, June 4, 2013.
Lynn, Nathan Blake. "FW: jd wilkes contact?" e-mail to author, April 30, 2013.
Madden, Larry. Personal communication, November 2009.
Matthews, David. Personal communication, June 4, 2013.
Melton, Calvin. Personal communication, June 3, 2013.
Oberst, Mike. "RUSS-Edit and send to Mike Oberst" e-mail to author, May 22, 2013.
Oglesby, J.T. "RE: Barn Dance" e-mail to author, March 13, 2013.
Prather, Bob. Personal communication, May 14, 2011.
Settle, Lloyd. "RE: Barn Dance" e-mail to author, March 13, 2013.
Sexton, Lee. Personal communication, December 2009.
T Claw. Personal communication, February 15, 2013.
Wagoner, David. "Carlisle County" e-mail to author, June 18, 2013.
Waldron, Judy. "RUSS-Edit and send to Mike Oberst" e-mail to author, May 22, 2013.
Walker, Stanley. Personal communication, July 17, 2013.
Webster, Larry. Personal communication, July 5, 2013.
Wells, Jessey Ray. "RE: Western KY Music" e-mail to author, January 12, 2012.

FILMS

Cohen, John (producer). (1963–2010). *The Legacy of Roscoe Holcomb* [Film]. Newton, NJ: Shanachie Entertainment Corp.

Seeger, M. (producer), and R. Pershing (producer). (1984–1991). *Talking Feet* [Film]. Washington D.C.: Smithsonian Folkways.

HISTORICAL LETTER

Clark, Wm. (1827, April 27). Letter. [William Clark writing to his son Lewis]. Archived Material. Missouri Historical Society. St. Louis, MO.

INDEX

ND



Cope, Joe 83
Cornett, Banjo Bill 98
Country Music Warehouse 61
Country Place Jamboree 64
Cowan Creek School 122, 124

D

"Dare to Be Square" 123
Davis, Fonzy 15
Dunlap, Eddie 36

E

English, "Plucker" 57
Everly, Ike 45, 51, 54, 55, 56, 57, 59
Ewens, Ed 29

F

Felt's Music Place 93
Ferrell, Jonathan 46
Fields, Willis 124
Foley, Red 66, 67, 69
Fothergill, Joe 64, 70
Foxfire 119
Frankfort First Baptist Church 92

G

Gage, John 103
Goforth, Kentucky square dance 98
Grand Ole Opry 15, 16, 17, 29, 35, 37, 39, 60, 66, 69, 70, 76, 91

H

Hall, Charlie H. 22
Harrod, John 116, 121, 122, 125
Hartford, John 55
Hatfields 120
Hay, George D. "Judge" 16
Hebron Masonic Lodge 113
Hemphill jam 137
Hendrickson, Layne 31
Henson, Scottie 33
Hideaway Saloon 109
Holcomb, Roscoe 98

Home of the Legends Jam 61
Homer and Jethro 67
Hudson, Frank 51, 52, 55, 57
Hurst, Tommy 79

I

International Bluegrass Music Museum 46
Irish jams 93

J

Jett, Richard 126, 129
Jim's Opry 55
Jonathon, Michael 75, 103
Jones, Alice DeArmond 56
Jones, Frank 29
Jones, Kennedy 56, 57, 59
jug band music 95

K

Kazee, Buell 98
Kentucky Blue Belles 106
Kentucky Country 67
Kentucky Explorer 70, 117, 132
Kentucky Sassafras 106
Kinman, Matt 122
Kirtley, Rodney 53

L

LaFarge, Pokey 96
Lair, John 66, 70
Lamb, Lewis 73
Lanham, John 50
Last of Callahan 116
Ledford, Lily May 69, 125
Lee, Ernie 67
Leitchfield Open Jam 93
Lomax, Alan 133
Long Ridge Jamboree 122
Lost Indian 117
Louisiana Hayride 17, 31
Louisville square dance 99
Lynn, Loretta 17, 139

Sumner, Marion 118, 124, 138
Sun Studios 17, 37, 39

T

Taylor, Ballard 98
Taylor, Tommy 98, 110
T Claw 98, 99, 101, 102, 123
Thompson, Hank 79
thumbpicking 53, 54, 55
Tillers, the 65, 96, 99, 102
Travis, Merle 45, 51, 54, 55, 56, 57,
 58, 59
Trim, Oved 39
Troy, Leroy 75, 96

V

Verona Lake Ranch 98

W

Wagoner, David 64
Walker, Stanley 29, 32, 37, 38, 39, 41
Walker, Wilburn 39
Warren, "Uncle" Henry 106
WCBL 39
Webster, Larry 120
WHAS 66, 70, 95, 105
Wheeler, Mary 24, 26, 27, 28, 133
Whiskey Bent Valley Boys 90, 110
Whitaker, Charlie 125
Williams, Josh 90
Willie's Locally Known 93
Willis Music 113
Winders, Eula 55
Windy Corner Market 64
WSM 15, 16, 119

Y

Yoakam, Dwight 139

ABOUT THE AUTHOR

J.D. Wilkes was born in Baytown, Texas, in 1972 but reared primarily in western Kentucky. He graduated from Murray State University in 1995 with a BA in art. He has since become an award-winning filmmaker, cartoonist and musician. He illustrated the book *Spookiest Stories Ever* for the University Press of Kentucky, and his comic art is published online at TopShelfComix.com. His southern documentary *Seven Signs* screened nationwide, receiving several awards at film festivals. It premiered in the UK at London's Raindance Film Festival.

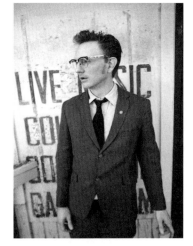

Wilkes has toured the world, playing harmonica and banjo in his bands the Dirt Daubers and the Legendary Shack Shakers. He has also recorded harmonica for Merle Haggard, Hank Williams III, John Carter Cash and the Grammy-nominated soundtrack for HBO's *True Blood*.

For his contributions to the Kentucky arts, Wilkes was commissioned the title of Kentucky Colonel and "Duke of Paducah." He and his wife, Jessica, live in Paducah.

Follow his travels online at facebook.com/jdwilkes, Instagram account @jdwilkes and his website jdwilkes.com.